D0475089

For Reference ✓

Not to be taken from this room

81-12269

Daly City Public Library
Daly City, California

CHRONICLE BOOKS
SAN FRANCISCO

50 WEST COAST ARTISTS

A CRITICAL SELECTION OF PAINTERS
AND SCULPTORS WORKING IN CALIFORNIA
by HENRY HOPKINS
Director, San Francisco Museum of Modern Art
with portraits of the artists by MIMI JACOBS
edited by DOUGLAS BULLIS

DC1 H

R
709.22
F

All rights reserved.
No part of this publication may
be reproduced or transmitted in
any form or by any means
without permission in writing
from the publisher.

*Library of Congress Cataloging in
Publication Data*
Main entry under title:
50 west coast artists.
1. Artists—California—Biography.
2. Artists—California—Portraits.
3. Art, American—California.
4. Art, Modern—20th century—
California.
I. Hopkins, Henry.
II. Jacobs, Mimi.
III. Bullis, Douglas.
IV. Title: Fifty west coast artists.
N6530.C2A13 709′.2′2 [B]
81-12269 AACR2
ISBN 0-87701-239-3

Editor's note:
The San Francisco Art Institute
was formerly called the California
School of Fine Art; the name was
changed in 1961. The San Fran-
cisco Museum of Art changed its
name to the San Francisco
Museum of Modern Art in 1971.

Chronicle Books
870 Market Street
San Francisco, California 94102

Acknowledgments:
A book with this many people
involved could not come into
existence without the assistance
of many others. The publisher,
producer, and each of the
artists owes a special gratitude to
the following: Kendal Andersen,
Paule Anglim, David Barich, Rena
Bransten, Carla Davidson, Rita
Fink, Roger Gass, Nona Ghent,
Dorothy Goldeen, Susan
Goldsmith, Wanda Hansen, Sam
Jacobs, Ann Kohs, Bill LeBlond,
Ann Merchant, Karyl Pullen, Larry
Smith, Gretchen Weiss, and
Linda Zimmerman.

*The following photographers and
museums or galleries have graciously
allowed the use of their work in
this book:*

William Allan: University Art Museum,
Berkeley, California.
Robert Arneson: Rosenthal Art Slides;
Des Moines, Iowa, Art Center.
Charles Arnoldi: Thomas Vinetz; James
Corcoran Gallery.
Ruth Asawa: Roger Gass; Samuel
Merritt Hospital, Oakland.
Robert Bechtle: Courtesy of the artist.
Fletcher Benton: M. Lee Fatherree;
courtesy of the artist.
Tony Berlant: Frank Thomas; Xavier
Fourcade Gallery.
Elmer Bischoff: M. Lee Fatherree; John
Berggruen Gallery.
William Brice: Grant Taylor; Edward
Downe.
Joan Brown: M. Lee Fatherree; courtesy
of the artist.
Vija Celmins: Daniel Zimbaldi; Fort
Worth Art Museum, Benjamin Tillar
Trust Fund.
Judy Chicago: Mary McNally;
anonymous.
Jay DeFeo: Courtesy of the artist.
Roy De Forest: Courtesy of the Hansen
Fuller Goldeen Gallery.
Tony Delap: Douglas M. Parker Studio;
Dr. Roger Stinard.
Richard Diebenkorn: Douglas Bullis;
courtesy of Rena Bransten.

Guy Dill: Alan Berliner; courtesy of
the artist.
Laddie John Dill: John Thomson;
courtesy of the artist.
Claire Falkenstein: Adam Avila and
Paul Showalter; proposed installation
for California State University,
Dominguez Hills.
Sam Francis: Courtesy of the
Litho Shop.
David Gilhooly: Courtesy of the artist;
William Shelley Collection.
Sidney Gordin: Robert S. Boni; Mason
Wells Collection.
Lloyd Hamrol: Michael Mouchette;
New Mexico School of Law,
Albuquerque.
Tom Holland: M. Lee Fatherree;
courtesy of the artist.
Robert Hudson: Courtesy of the artist;
Federal Building, Anchorage, Alaska.
Robert Irwin: Courtesy of the artist;
San Diego State University Museum
of Art.
Craig Kauffman: Nancy Hirsch;
Asher/Faure Gallery, Los Angeles.
Helen Lundeberg: Courtesy San
Francisco Museum of Modern Art.
Richard McLean: Courtesy of the artist.
Lee Mullican: Frank Thomas; Galerie
Schreiner.
Manuel Neri: M. Lee Fatherree;
Mr. and Mrs. Mark Cluett.
Nathan Oliveira: M. Lee Fatherree; John
Berggruen Gallery.

Joseph Raffael: Roger Gass; Nancy
Hoffman Gallery.
Mel Ramos: Courtesy of the artist;
Louis K. Meisel Gallery.
Fred Reichman: Karel Bauer; courtesy
Nancy and Dan Tandberg.
Sam Richardson: Courtesy of the artist;
Santa Barbara Museum of Art.
Ed Ruscha: Susan Haller; courtesy of
the artist.
Betye Saar: John Thomson; courtesy of
the artist.
Raymond Saunders: Bill Jacobson;
Stephen Wirtz Gallery.
Richard Shaw: Phillip Galgiani; San
Francisco Museum of Modern Art.
Louis Siegriest: Peter Brown;
Triangle Gallery.
Wayne Thiebaud: Courtesy Allan
Stone Gallery.
Michael Todd: Courtesy of the artist;
Charles Cowles Gallery.
DeWain Valentine: John Forsman;
courtesy of the artist.
Leo Valledor: Courtesy of the artist.
Peter Voulkos: Roger Gass; City and
County of San Francisco.
William Wiley: M. Lee Fatherree;
courtesy of the artist.
Emerson Woelffer: Dina Woelffer;
courtesy of the artist.
Paul Wonner: Courtesy of the San
Francisco Museum of Modern Art,
Charles H. Land Family Foundation
Fund Purchase.
Norman Zammitt: Marilyn Zammitt;
courtesy of the artist.

Contents

5

50 *West Coast Artists* is a selection of American visual artists who have chosen to live and work in California. It is our hope that this is only the first in a series of similar volumes which will continue to document painters, sculptors, photographers, printmakers, architects, filmmakers, craftsmen, and designers from this section of the nation. ℂ This publication is not intended to be a tome laden with critical content but rather a document which provides the reader with a chart for recognition: the artist's face, name, a reproduction of a favorite work, and a brief personal statement of intent or attitude. ℂ The book can be treated lightly, like a high-school yearbook that provides the justification for a walk down memory lane, or it can be considered a serious attempt to put more documentation of this vast creative arena down on paper. Its value will increase as more books in the series are produced. Additionally, the publisher plans more intensive volumes of monographs and movements, written by authors of intellect and sensitivity. ℂ The selection of artists for this work

was a matter of cooperation between myself and Mimi Jacobs, who in mid-life trained herself to become a talented portrait photographer. She then embarked on the endless project of documenting in photographic form the artists of California. It was her belief—as it is mine—that some of the most charismatic heads in the world sit on the shoulders of people who have dedicated themselves to lives of creativity.

The selection process began several years ago with an imperfect list drawn up to serve as a guide. Names were then added, and continued to be added as the project began to flourish. The reader can guess that the first phases were not easy. Nonetheless, Mimi Jacobs found some sitters and, as her portraits began to appear in catalogs and on book jackets, the task became easier. Exhibitions of her work at the San Francisco Museum of Modern Art, the Los Angeles County Museum of Art, and the Oakland Museum helped, as did the inevitable word of mouth.

Even so, Mimi prefers to work in the environment of the artist, which requires a significant amount of travel and patience. Many artists on her list have not yet been photographed. Many talented artists who might well have been included were omitted because of limited space. There were one or two artists who quite simply did not wish to be photographed. A few others preferred not to be part of an anthology, and still others did not wish to be considered "California" artists.

The question of local designation is a continuing problem for those who work in the world of art history and documentation, as well as for the artists. It is, however, a matter of accuracy. No one has difficulty with such titles as "Dutch Art of the Seventeenth Century" or "Italian Painting of the Quattrocento" or, even more specifically, "The Florentine Painters of the Renaissance" or "Venetian Masters," even when every artist included is of recognized world class. California is a land mass larger than any

European country, and Los Angeles is larger than any of those cities mentioned above. I believe that being an artist who chooses to live and work in California has something to do with the philosophical and aesthetic nature of the work produced. This fact in no way hampers the artist, and may even enhance his or her capacity to achieve international stature. If there is a problem, it seems to emerge from the unspoken and unchallenged tendency on the part of New York writers to assume that artists living and working within a hundred-mile radius of New York City represent the mainstream of American art and therefore don't require a "New York" designation. Such a title as "American Painting of the 80s," a recent exhibition selected by Barbara Rose almost exclusively from artists working in New York, is not only misleading but harmful.

I am becoming increasingly convinced—admittedly a biased opinion—that art currently being produced in California more clearly reflects the American mainstream than does art being produced in New York. Speaking geographically rather than politically, California should be considered a nation rather than a state. California is a good-sized patch on the crazy quilt of the world. Because of its size and its extended length, California can claim two definable and radically different physical, social, and political environments within its boundaries. One is centered in Los Angeles, the other in San Francisco.

Los Angeles spreads over the western landscape with no clearly defined boundaries. Only the Pacific Ocean limits its expansion west into infinity. Nearly three million people now live within its arbitrary limits. San Francisco squeezes its six-hundred-thousand-plus residents into a thumblike peninsula.

Los Angeles is youthful, brash, exploratory, new-money conscious, and exciting. San Francisco is matronly, dashing, old-money conscious, and exciting. San Francisco is heavenly.

Los Angeles is everyone's fantasy. Los Angeles colors are white, blue, and yellow (except on smoggy days, which everyone ignores). San Francisco's are silver, gray, and green. Is it any wonder that the art produced in these two distant centers is as different as the art produced in Florence and Venice during the fifteenth century?

The natural setting of San Francisco and its surroundings are extraordinary: the bay, the rough coast and its cold ocean, the rippling hills of Marin, the pine-covered ridges of the lower Peninsula. Almost every day presents a surprise of nature made up of Japanese, Norwegian, or Mediterranean skies, depending on the fog and the mini-chill in the air. The art of the area continues to come out of a hundred-year tradition that reflects this environmental beauty and the individual's response to it. Whether naturalistic, abstract, or playfully personal, the art emerges as a response to nature. This is particularly important when one

realizes that the majority of San Francisco artists don't live in urban San Francisco but rather in modest dwellings in the "country." The generalized response has been pure painting and sculpture characterized by heavy impasto; rich, dense color; strong steel; clay; wood; and rough plaster.

Of course, there are exceptions that prove the rule, but it is worth noting that the technologically pure art that comes from Northern California emerges largely from the anonymous environment of San Jose, sometimes referred to as Los Angeles North.

As a generality, the art of Los Angeles is clean, intellectually clear, high-colored, light-filled, and even light-constructed. There continues to be an unusual interest in new materials: glass, plastic, and synthetics. This tradition evolves from the earliest twentieth-century modernists who were interested in universal ideas rather

than nature. It could be said that the art of Southern California finds its impetus in Zen and Jung, while Northern California is oriented toward Sturm und Drang.

It is not my intention to link any artist irrevocably to a single place or to say that if he or she had to shift environments the art would fail. In fact, the opposite is true. It is because of this that my faith in the artists of California is constantly refreshed and renewed. It has been very rewarding to watch what happened when artists such as Richard Diebenkorn moved south and Peter Voulkos moved north. Their art changed to meet the new environments, but the art was not weakened. Other Californians, such as Jackson Pollock, Philip Guston, Richard Serra, Walter de Maria, and Dennis Oppenheim chose to shift to the strenuous environment of New York early in their careers and continued to excel and to feed on their new environment. Now the mainstream is beginning to flow down the western slopes of the Sierras.

California is more than a place; it is an idea. From its beginnings it has held a special place in the history of the nation.

In 1821 a revolution shifted California's government from a remote Spanish colonial society to a near-to-home Mexican provincial leadership. During the Mexican era, the Russians, the English, the Anglo-Americans, and the commercial influences of the Pacific cultures of China, the Philippines, and Hawaii began to shape the environment and to form a cosmopolitan atmosphere unique to the North American continent.

The Mexican wars of the 1840s, transfer of government to the control of the American military, and discovery of gold in 1848 brought thousands of people from every corner of the world to try their luck in this loosely formed and sparsely inhabited territory. Sizable communities made of a complex ethnic mix emerged almost overnight and, even more than in the

Eastern cities of that time, a true "melting pot" culture was established. Ideas and events—not to mention a variety of religious and social attitudes—produced a philosophy of tolerance quite beyond anything else in the American experience.

Throughout this formative period, the number of artists who came to document or take inspiration from the vanishing frontier and stayed on to affect the social structure was unusually high. Thus, even from the beginning, it has been justifiable to restate the perennial cliché that the footloose, the adventuresome, and the dreamers loom large in the formation of California's compatible but strikingly individualistic society.

It is this image of California as bigger and/or better than any "real" place that has been passed on from generation to generation throughout the world right up to the present time. California remains an incurable vamp. The image has been burnished and expanded on as California has presented itself through art, music, dance, theater, literature, and especially through film. Whether one is dealing with W.C. Fields's first sniff of the orange groves as he expatriates himself from the East, Gloria Swanson's delusions of grandeur in *Sunset Boulevard*, or the real lives of Marilyn Monroe, John Wayne, and Ronald Reagan, the line between the real and the unreal is paper thin. In other words, California is a wonderful environment for the creative temperament.

One short-time Californian observed, "Living in Los Angeles is like slowly sinking into a warm bowl of Farina." He was wrong. Much has been said of mankind's need for seasonal change as a temporal reminder and as a boost to mental tone. Californians don't need seasons to remind them that man exists at the whim of nature, for they have chosen to live within the shadow of the "Big One." Every day brings some reminder of finite existence. Each low-flying plane, each passing train that rumbles the foundations re-

12

minds us that this may be the last day in Nirvana. Living in California is extraordinary, but it is also a high-risk environment. In New York, you bet your winter boots; in California, you bet your life. And yet, people continue to come to the Pacific rim in ever-increasing numbers.

The 1980 census documented a continued and accelerating movement in population from cities in the northeastern United States to cities in the Sun Belt and on the West Coast. California has by far the largest population of any state in the nation, and cities such as San Diego, Los Angeles, San Francisco, and now San Jose, are ranked in the largest twenty in the country. In addition to the population shift, nine seats in Congress have been lost from the East and gained by the West, and the headquarters of major American corporations continue to move here.

This new, more sophisticated movement west can be linked to the rapidly growing trade relations with Japan and China, as well as to the continuing struggle of European nations to maintain a position of some strength within the international business community. It seems quite clear that soon this nation's center for world business may well be more appropriately based on the West Coast.

While the preceding seems indirectly related to art and cultural development, it is my anticipation that as people, business, and political power shift westward, the climate for the arts here will improve significantly. Support for this opinion is already well in evidence, since the growth and development of California cultural institutions over the past twenty years has been nothing short of dramatic.

The major developments are yet to come, however, and the next decade must see a considerable improvement in the cultural support system if the West is to aspire to parity with the East as a center of national and international cultural influence.

Californians interested in the visual arts have known for some time that there is no lack of artists of distinction who have chosen to live and to work in this state. In fact, a remarkably high percentage of the best-known American artists have been, at one time or another, Californians. Unfortunately, in far too many cases their reputations have been established elsewhere since the Western cultural support system has been perpetually in low gear if not reverse. For this reason many of the best and the brightest artists found it necessary to move to New York, "where the action is." We have had to live with the fact that museums, economic resources symbolized by galleries, and most of all, publications that deal consistently and intelligently with the arts are more numerous and far superior in New York.

Eastern museums have an advantage in their remarkable permanent collections. Any object or period of art that one might wish to see or to study is only a bus ride away. In New York, changing exhibitions are the frosting on the cake. Just the opposite is true of California museums, where changing exhibitions serve as the cultural lifeline for those who want and need to know about art and spotty permanent collections only modestly amplify or surround the exhibition program. Public and private Eastern collections were established earlier and pursued more diligently. Even a massive infusion of money into the collections of California museums would not rectify the imbalance, especially for the art of the past, since most of the primary masterworks by earlier artists are already in public institutions and unavailable at any price. Museum curators must continue to make every effort to get every major work in California private collections into a California museum. But what is promising is the fact that we can now begin to meet the competition head-on for work created presently and in the future. The collecting pattern of the Museum of Modern Art in New York has taught us how quickly the present becomes the past and how quickly master status can be bestowed upon an artist who may now be in mid-career.

New York galleries have been more successful than California galleries for several reasons. Chief among these is that New York is still the biggest, busiest, and most sophisticated city in the nation, which breeds competition and demands brilliant performance for survival. Another reason is that New York dealers understand that gallery success is based on selling and promoting the work of the artists whom they have chosen to represent, and they are willing to make the commitment required to achieve success. With a few notable exceptions, California galleries are just beginning to recognize that they have more than a good-hearted educational role to play and that they can play the success game, too. This revelation comes at a propitious moment since a much larger and more demanding audience is developing around them.

There is a third reason for the success of New York galleries: art publishing and critical writing. In the United States, all art publishing of significance, whether it be a book, art magazine, or weekly news magazine, is centered in New York. This is perhaps the most important reason for that city's continuing dominance as the nation's center for art activity. Museum and gallery exhibitions are visited by a reasonable number of interested people, but these same exhibitions are read about by millions. Art becomes art history through the published word accompanied by images. Exhibitions about which little or nothing is written fall by the wayside.

Virtually all American and most English-language art books are selected and published by New York editors or are distributed nationally and internationally by them. Every American art magazine of stature is published in New York and the articles in them are selected by New York editors. Is it any wonder that an artist of significance from California, Texas, or Chicago has difficulty being written about until he has had some successful exposure in the "Big Apple"?

The *New York Times* is the only national newspaper that consistently and intelligently deals with criticism and documentation of the events of the art world on an almost daily basis. But, because the *Times* is a New York newspaper, an occurrence in some other section of the country must be of unusual importance to be recognized. The *Los Angeles Times* seems now to be aspiring toward more complete coverage, yet it is difficult to imagine New Yorkers lining up at the newsstand on Sunday morning to buy the *Los Angeles Times* primarily for its cultural coverage. Most other California newspapers communicate only with subscribers and purchasers within a hundred-mile radius of their community of origin.

Weekly news magazines that cover the arts in a reasonably consistent fashion have been more responsive to events outside of New York because they recognize that an increasingly large portion of their subscribers live in the West.

If these last few thoughts have a seemingly negative ring to them it is only because I am attempting to describe as accurately as possible what it will be necessary for us to do if the West Coast is to become an even stronger center for cultural recognition.

California is bursting at the seams with creative activity. What has been said here about the visual arts applies as well to music, dance, theater, and poetry. Almost every aspect of art activity has reached a new plateau of originality and maturity. The artists are here. The organizations that support them are staffed with well-trained people who are used to competing in the national arena. There are even some mini-signs that art publishing is on a qualitative and quantitative upswing.

The challenge for the next decade is to provide a support system capable of laying claim to on-going cultural parity with the East.

A Note from the Photographer

I *have always* been fascinated that each person frequently reveals a transitory facial expression that is a unique aspect of his or her personality. My goal is to attempt to capture that fleeting moment with simplicity and unpretentiousness. The collaboration between the subject and the photographer interests me enormously. Every aspect of photography, especially the magic in the darkroom, excites and exhilarates me.

Photographing the artists for this book was an intriguing challenge. I attempted to reveal the artist as a human being as well as a creator. This project provided me with an insight into many diverse personalities as well as an added appreciation and understanding of the nature of the artists' works.

I am most grateful to Henry Hopkins for believing in me from the beginning.

This project was enhanced by my husband's devoted assistance, judgment, and enthusiasm. I thank him with all my heart.

Mimi Jacobs

50 WEST COAST ARTISTS

NORTHERN CALIFORNIA

The art of Northern California has evolved along traditional lines, beginning with a physical and social environment conducive to the creative temperament. The result has been an unbroken line of artists of consequence from before the turn of the century to the present. ⊄ Because San Francisco is probably the most cosmopolitan and democratic of the nation's cities, a live-and-let-live attitude has developed which provides for sharing yet also carefully guards the rights of individual freedom. This freedom is the key to the highly personalized art that emerges from the area. It is difficult to imagine any other region that could spawn such a diverse lot as William Wiley, Fletcher Benton, Wayne Thiebaud, Leo Valledor, and Nathan Oliveira. Freedom is the first reason, but a secondary reason for this rich mixture could be as simple as the fact that the San Francisco Bay Area is a rural/urban environment that is adaptable to the needs of every personality. Long before the Beat and the Flower generations, the city and its surroundings found new ideas growing in its midst and nurtured them until they became assimilated into the mainstream of American life.

William Allan

At *about thirteen* I wanted to be an inventor. I was disappointed that most of the important things in life had been invented—the steamboat, light bulb, cotton gin, etc. My education at the time repeatedly verified this. As a high-school student in eastern Washington, just before my athletic numbers were indelibly printed on my hide, I met my first poet: art teacher Jim McGrath. He was an extraordinary inventor, unlike any in my past experience. He made life a large place concerned more about possibilities than about victory or defeat. Robert Hudson and William Wiley were in the same school. Later, like Franz Kafka immigrants, we found our way to the California School of Fine Arts.

While in Washington, we also met Phil McCracken, an artist and another kind of poet, a deep, caring person with values that were about giving. Later on other poets appeared—Carlos Villa, William Geis, Joseph Raffael—each adding something different about how things could be done, how things could be invented. As I watch the poet develop in my children—Jill, Jess, and Reese—I am reminded of the necessity of my own poet.

Shadow Repair for the Western Man was painted at a time when I was becoming aware of changes in myself and the culture around me. The traditional image of what a man represents was fading. There was a new wilderness to pioneer that didn't require the same tools as the last. The necessary tools now were not so obvious. Perhaps the new frontier was something to understand rather than conquer. Perhaps the tools didn't need to be sharper, but better weighted.

We were casting formidable shadows at curious and potentially valuable innocents—ourselves. Nature is powerful and distant. Not that it is dangerous or cold, but for it to exist, like ourselves, it must be paid attention to.

Shadow Repair for the Western Man • acrylic on canvas • 1981 7' by 10'

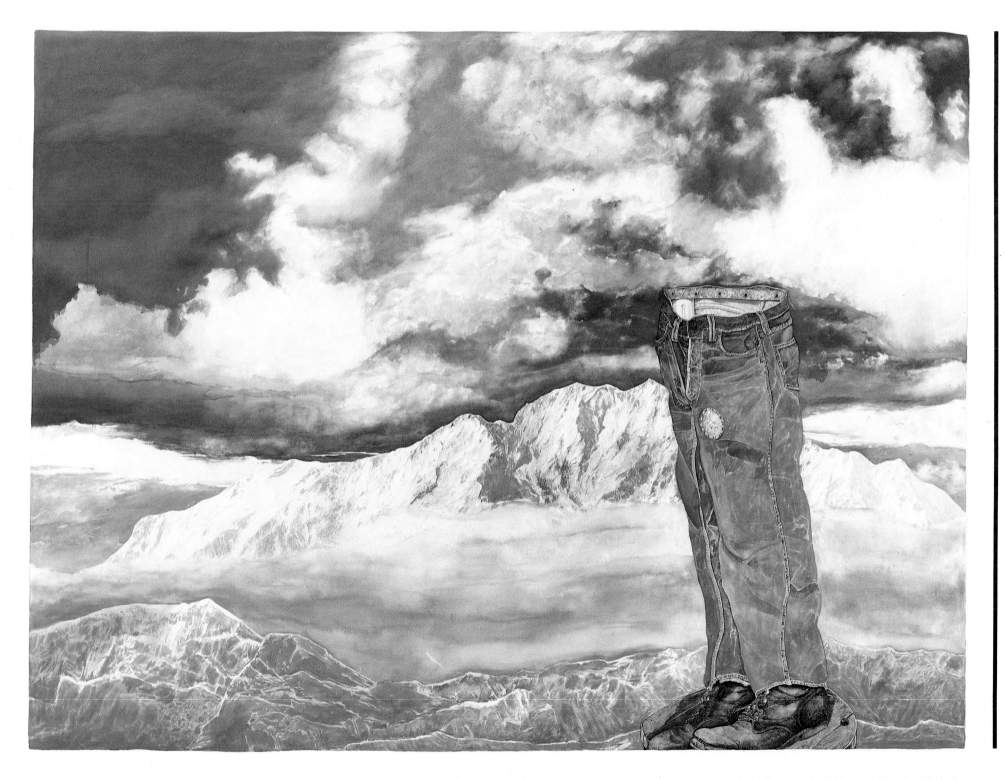

Robert Arneson

I *was born* and raised in Benicia, California. As a youngster I used to draw comic books featuring myself as a super sports hero. I drew while lying down on the front room floor, which often caused a pain in the chest. I remember spilling a bottle of black India ink on the carpet. Mom almost ruined my budding artistic career. Fortunately Dad came to the rescue and I got on with the next chapter.

Later in high school I drew sports cartoons of all my buddies for the weekly *Benicia Herald*. I thought this might become my true avocation. However, some commercial art classes at the California College of Arts and Crafts in Oakland ended that illusion.

It wasn't until I taught some high-school classes in Menlo Park, California, that the ceramic "bug" bit me. Later, when I was studying pottery at Mills College in Oakland, I was turned on to the work of Peter Voulkos. I eventually worked through his influence to the stuff I hate to mention called "funk" art.

24

That's me inside that head, attempting a tongue-in-cheek U-no-Hu self-portrait. This piece is an example of what I've been up to for the past ten years.

I like art that has humor, wit, irony, and playfulness. I want to make "high" art that is outrageous while revealing the human condition, which is not always high. The danger in this is that the artist can create some silly stupid stuff. So I ask myself, "Why play safe? Clay can't hurt you. Besides, it's informal."

For about the past ten years I've been modeling over-sized portrait heads of myself (and other infamous artists) in clay and glazing them colorfully. I like to work with faces that talk back to you dead in the eye. After all, faces are what most of us mortals relate to—certainly I do. The human face, unlike the frog's or monkey's, is a window on the mind.

As far as influences go, I know of the eighteenth-century artist Francis Messerschmidt, but I like to think that my sculptures look back to the Greeks and the Romans. However, the final authority is vested in my kiln, which has on many occasions outdone my original intentions.

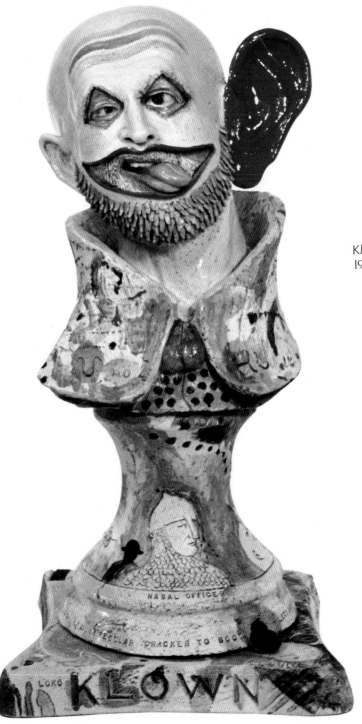

Klown • polychromed ceramic
1978 • 37" by 19" by 19"

25

Ruth Asawa

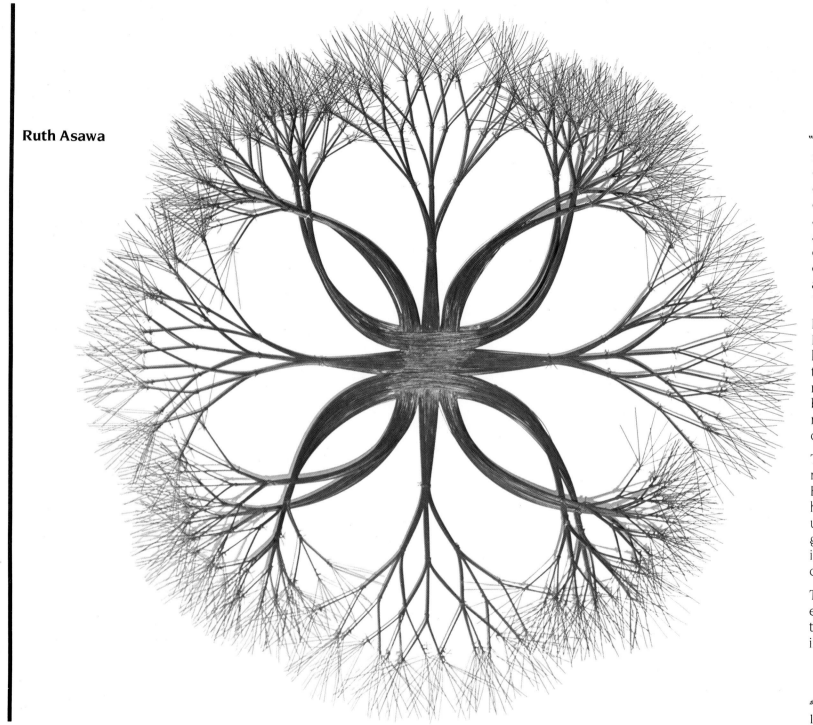

"**W**here do your ideas come from?" is a question I'm often asked. The best ones come unexpectedly from a conversation or a common activity like watering the garden. These can get lost or slip away if not acted on when they occur. We are often too busy with "real" work.

In 1962 our friends Ginny Hassel Ballinger and her late husband, the photographer Paul Hassel, returned from the desert bringing my husband and me a plant. "Here's an exercise in drawing," Paul said.

The complexity of the plant made it impossible to draw. By constructing it in wire, however, I could begin to understand the interwoven growth pattern. This led me into electroplating, bronze casting, and resin casting.

This sculpture represents an early development of the tied-wire series that was inspired by the small plant.

#71 · welded copper · 1965
12″ by 6″ deep

26

My *father and mother* taught me to respect work. My cousin Henry encouraged me to draw. My seventh-grade art teacher, Gwendolyn Cowan, taught me watercolor. Edith Lowe, my high-school art teacher, encouraged her students. Tom Okamoto introduced his students to the professional approach to art, telling us, "Draw, draw, draw." Robert von Neumann and Joseph Friebert taught and exhibited and introduced us to many other artists and to the struggles of being an artist. Josef Albers taught us to see and to integrate art into our daily lives. Buckminster Fuller told us, "The world is your oyster." Imogen Cunningham exchanged ideas, photography, plum jam, and plants, and shared a birthday with my husband, Albert. Albert encouraged me to work and managed to keep his sense of humor throughout our thirty-two years of hard work, making a living, raising our family, and now enjoying the fruits of our labor, our grandchildren.

27

Robert Bechtle

I *grew up* in the East Bay and started drawing when I was a kid. My mother was a teacher. She and my other teachers encouraged me. By the time I reached high school, I knew I wanted to be an artist. There wasn't anything else I was interested in. I went to the California College of Arts and Crafts in Oakland—four years in graphic design and two years graduate work in painting.

There are critical years after school when you are trying to find out what you want to do with your work. Early on, I was interested in the work of Richard Diebenkorn and Nathan Oliveira, partly because of their example as artists and partly because of their art. A lot of what I do grows out of their work— not in style but in structure, in organization. One reason my paintings have become so realistic has to do with my interest in what things really look like. That concern has caused me to drop my brushiness gradually, to tighten things up, and to be concerned more and more with actual physical appearances.

I *am interested* in how things look. I am also interested in painting based on how things look. I look at things the way they are rather than thinking how they can be changed. The richness and range of the visual world constantly thrills and amazes me. I am most interested in using the part of the world that we least notice, our everyday surroundings as we live day to day. Thus, I have painted friends and family, familiar houses, neighborhoods, and automobiles. On one level the paintings are about middle-class life as observed in California. On another, they are about reconciling that subject matter with my concerns about issues of formal painting—the use of color and light, design, and the kinds of marks one must make to replicate appearances. In that sense, they are a part of a long tradition of Western European and American painting that seeks to find significance in the details of the commonplace.

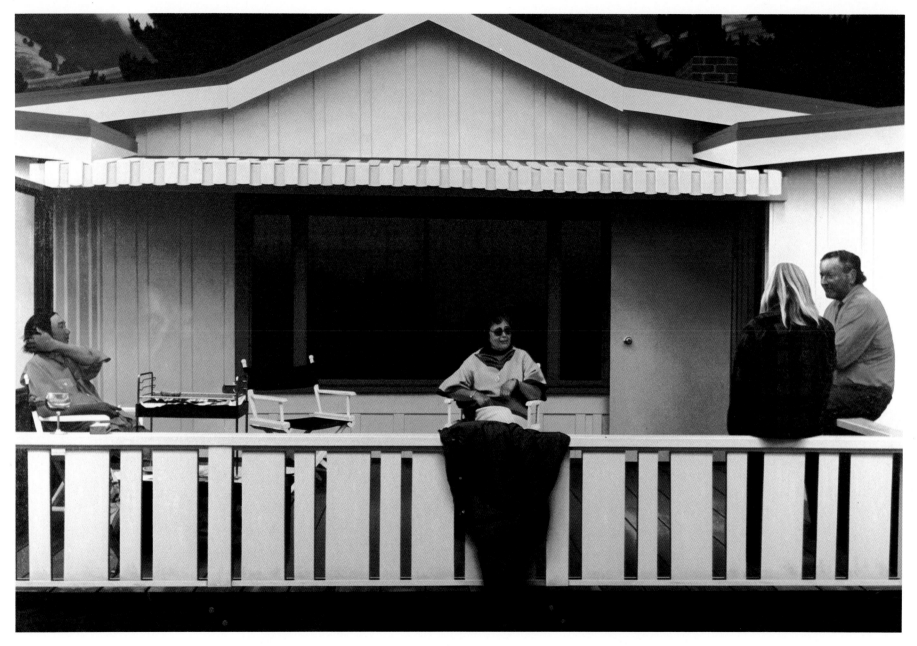

Stinson Beach Cook-out • oil on
canvas • 1979 • 48″ by 69″

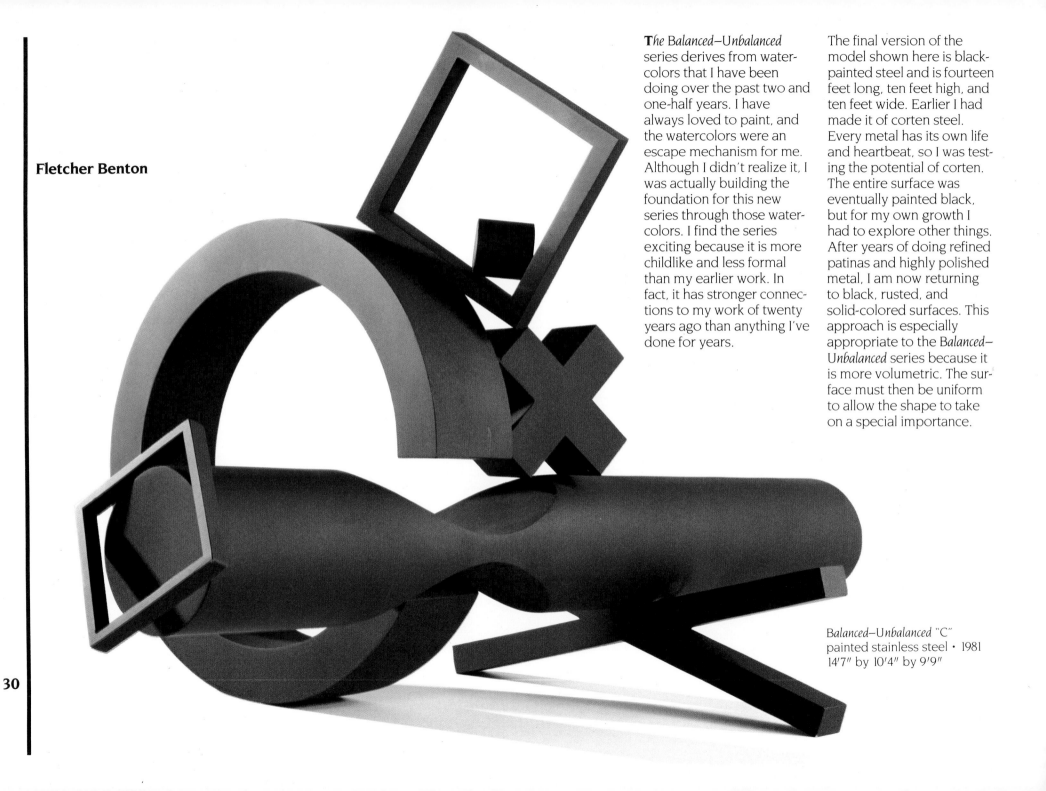

Fletcher Benton

The *Balanced–Unbalanced* series derives from watercolors that I have been doing over the past two and one-half years. I have always loved to paint, and the watercolors were an escape mechanism for me. Although I didn't realize it, I was actually building the foundation for this new series through those watercolors. I find the series exciting because it is more childlike and less formal than my earlier work. In fact, it has stronger connections to my work of twenty years ago than anything I've done for years.

The final version of the model shown here is black-painted steel and is fourteen feet long, ten feet high, and ten feet wide. Earlier I had made it of corten steel. Every metal has its own life and heartbeat, so I was testing the potential of corten. The entire surface was eventually painted black, but for my own growth I had to explore other things. After years of doing refined patinas and highly polished metal, I am now returning to black, rusted, and solid-colored surfaces. This approach is especially appropriate to the *Balanced–Unbalanced* series because it is more volumetric. The surface must then be uniform to allow the shape to take on a special importance.

Balanced–Unbalanced "C"
painted stainless steel · 1981
14'7" by 10'4" by 9'9"

30

As far as scale is concerned, most sculptors have appetites that cannot be satisfied. The bigger the sculpture is, the more dramatic it becomes. Painting deals with illusion and magic, whereas sculpture has a dynamic physical presence. I usually start out with a small wooden model about a foot tall. If I like it, I make a larger maquette. Each successive size holds a different experience for the viewer, from something so personal and small that it can be held in the hand to a piece beyond life-size with which one has a profoundly physical relationship. I need to experience those different levels of involvement. They engage me with the work in a manner no other method allows.

Although *there weren't* too many opportunities to become acquainted with art in Jackson, Ohio, my family would go to the Big City twice a year. I remember my mother taking me to Cole's Art Store in Columbus. It was probably one of the most exciting experiences of my life! Seeing all the paints lined up in rows, the brushes, crayons, and pastels—I've never forgotten it.

I always liked to entertain myself and I soon found that I could play with color endlessly. I enjoyed building models and feeling the sense of accomplishment in seeing something to completion. About the age of twelve, I attended a local Saturday afternoon painting class taught by Max Hendershot. Over and over, I copied his collection of 1940s calendar-art landscapes, seascapes, and still lifes. I think it was the exciting experience of taking the raw color and seeing an image take shape before my eyes that hooked me on art.

Most people have little control over their lives. They have to work according to someone else's schedule and on things chosen by others. I believe that people who choose to be artists do so in part to have freedom of choice in as many areas of their lives as possible. This is certainly one of the reasons I have stayed in art all of these years; sometimes I think it is less that I persist in being an artist than that I resist being anything else.

I don't recall ever making a deliberate decision to be an artist—it just sort of rolled along and I simply *was* one. Of course, it is also fun and I stick with it because making art gives more pleasure than anything else I can think of. Even in the hard times, I realized that the only thing I had of any significance was the power to choose—at any time—*not* to be an artist. On the other hand, no one could ever take being an artist away from me. Being able to produce something and then make a judgment on it is a catalyst in my life and what holds everything else together.

Elmer Bischoff

During *most* of my grade-school years I drew and painted with watercolors and played the piano and violin. Two of my uncles did cartooning as an occasional hobby. One played the ukulele, the other played the banjo, and my mother and older brother played the piano. I grew up with "Maple Leaf Rag," "I Can't Give You Anything but Love, Baby" and "The Minute Waltz" in the air, and Maxfield Parrish reproductions on the walls. My environment was filled with art in one form or another.

I took art courses in high school and when I went to college I majored in art, though my father, who was a builder, wanted me to study architecture. (I tried it briefly, with disasterous results.) Soon after returning to art I experienced a great awakening: I was introduced to Picasso and Braque. That was the end of Maxfield Parrish and the beginning of my commitment to painting.

In my formative years, two teachers in particular were very important to me: Margaret Peterson and Erle Loran, both at the University of California in Berkeley. This was the first time I had personal contact with people whose lives centered on art. Later on, through my association with the San Francisco Art Institute (then called the California School of Fine Arts) I had the good fortune to become closely acquainted with David Park, Hassel Smith, Richard Diebenkorn, and Frank Lobdell. I owe much in the way I see and think about art to these friendships.

I work in a studio away from home, am married to an artist, and have six children—three of them musicians.

The individual images in my paintings arise spontaneously with little coaxing, but I have difficulty finding out what they want to do other than sit still and have their portraits painted. Consequently, they and their collective life—the composition—require prolonged reforming and reordering.

I want the composition to be a total event determined by the will of the individual images. For this, I have found the most helpful state of affairs within the canvas to be one of dynamic interactions bordering on anarchy.

#54 · oil on canvas · 1980
80″ by 72″

33

Joan Brown

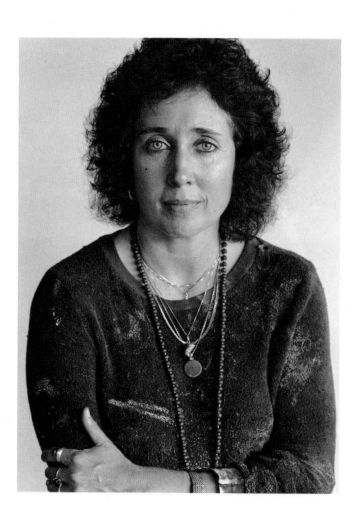

In my early years as an artist I was very influenced by Expressionism, Impressionism, and the Old Masters—mainly Rembrandt, Goya, and Velázquez. My most influential teacher was Elmer Bischoff, who was a very strong and positive influence. In the last few years I've been particularly interested in the work of Mark Rothko. Mysticism and Eastern thought have been an influence on my life and my art.

I've been to Europe, South America, Egypt, China, and India, and look forward to spending much more time in India. For me, the purpose of travel is to study ancient belief systems and comparative religions. I am fascinated by the similar threads that run through the ancient cultures. Certain images, ideas, and impressions that are particularly meaningful to me appear in my work after my journeys. I'm always surprised to find out what I was most impressed by after I've had a chance to assimilate everything.

For several years now I've performed the daily ritual of swimming in San Francisco Bay. I like to do it at the end of the day, near sundown, when the light on the water is very beautiful and peaceful. I depend on this swim. It both relaxes and energizes me. It is actually a form of meditation, and many of my ideas for paintings have materialized while I'm out on the daily swim.

Throughout the twenty-five years that I've been painting, my work has dealt with introspection. It can result from observation, actual experiences, feelings, thoughts, ideas, and/or intuition. I strongly feel the need to put this introspection in the form of pictures. I then become the "student" and consciously "study" the content of the pictures I have painted. This is why I choose to keep many of my pictures around me. The form or image varies, but the content is the same. Sometimes it is quite graphic, as in the self-portrait I chose for this book. Looking in a mirror, becoming a spectator, literally describing myself, is a very graphic way of being introspective. Other times the work is more narrative. My paint handling changes to whichever technique I feel will best describe what I am trying to express.

I strive for that delicate balance between reason and feeling, knowing that sometimes the pictures will lean one way or the other. I'm constantly trying to pull out new information from my intuitive self, which results in the surprises that I discover in my work, and which keeps me ever stimulated.

I hope to share with other people who view my pictures my own inward journeys, to which I hope they can relate on some level as being similar to their own.

35

Self-portrait at Age 42 • enamel on canvas • 1980 • 6' by 5'

Jay DeFeo

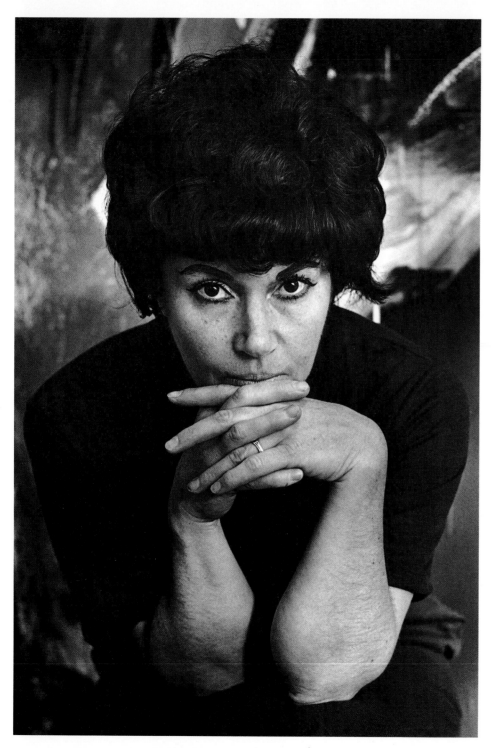

When I *graduated* from the University of California at Berkeley in 1951, I received a Sigmund Heller Traveling Fellowship and left for a year and a half of study in North Africa, Spain, France, and Italy. During my art history courses I had become very interested in the art of the Renaissance and of prehistoric peoples. At the same time I was increasingly affected by Abstract Expressionism, especially through my friendship with Sam Francis in Paris. When I returned to the United States, all these influences came to find their expression in sculptural works. When I returned to painting in the mid-fifties, I brought to it the sensibility of a sculptor.

Experimenting with new combinations of materials in order to express new ideas brought about a re-education in my life as an artist. Although my recent imagery is related in essence to my earlier work in oil, acrylic and mixed media have given me increased control and freedom. My concern with space is presently being expressed in terms of illusion on a two-dimensional surface, rather than the relief surfaces that typified my response to oil.

I *chose this* because it is the first significant painting I did after completing my major work, *The Rose*, in 1964. It marks a change from oil to acrylic and mixed media. Although I am known as a painter, I have sculptural concerns in my painting and have done sculpture in the past. The medium of oil led to sculptural expression. The change to acrylic and mixed media allowed me a more illusionistic treatment of volume, in the Renaissance tradition. This reflects my concern with expressionism and freely painted surfaces as well as areas treated with refinement and precision.

My ideas often emerge in response to materials and elements of chance. I enjoy investigating form, exploring the many possibilities of a visual idea. My early interest in black and white was triggered by Abstract Expressionism. I personally consider my palette to be one of limited color range. I am as interested in texture as in color, and texture is often closely connected to my choice of color. Photography is interesting to me for the same reasons, and my work in photo collage emerged from that.

Crescent Bridge #1 • acrylic and
mixed media on wood • 1971
4′ by 6′

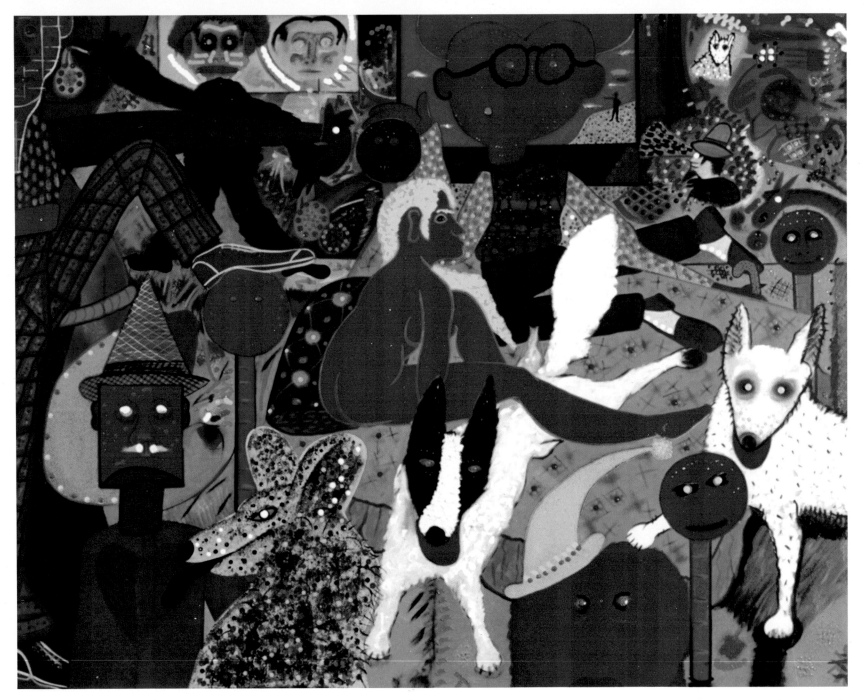

Private Lives · acrylic and vinyl polymer · 1981 · 70″ by 89″

I *was inspired* by a Stanley Spencer painting of a group of people on a bed. I substituted my dog Ratu as the bed's major occupant. Then, for a complete representation, I drew from classical art history and personal sources.

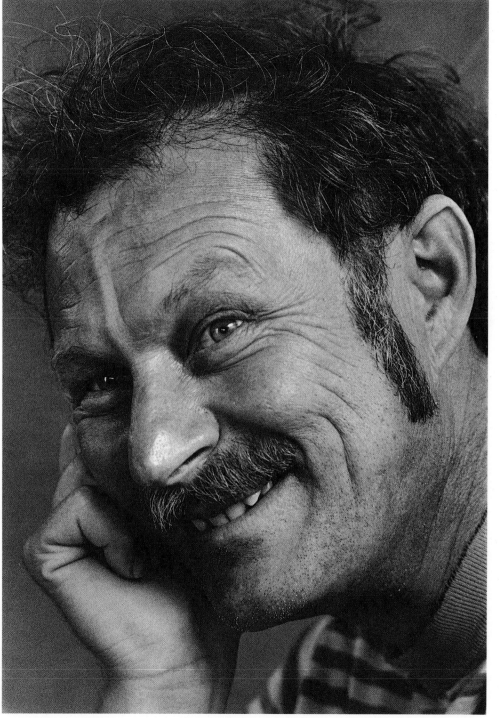

I *came into* this existence and through defined act or chance became an artist. I find myself midstream, with a critical understanding of my past as a painter and a great deal of hope engendered by my vision of a pictorial and artistic future.

David Gilhooly

I *was madly* in love with an art major in my early university days, when I was still enrolled in anthropology. It was spring, and to impress her I enrolled in two art classes the following fall semester. She married a Marine that summer and I never saw her again, but I was still stuck with the two classes—one with Robert Arneson and the other with Wayne Thiebaud—plus a class the following semester with Arneson and William Wiley. I got a piece in a show that semester (I don't like to waste time). I even sold my first work that Christmas in a little shop run by a student in Davis, California, called Godot's (as in *Waiting for. . .*). Then I changed my major and Arneson made me his assistant. I learned to stay away from girl art majors on a personal basis.

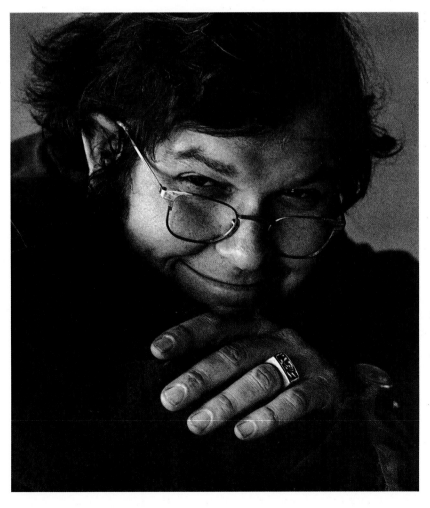

Things were fun at the Cal Davis campus in the 1963-through-1967 years. There was a group of people who wanted to be artists rather than just students and teachers. We all worked together daily. By 1966 Chris Unterseher was making his Boy Scout things, Margaret Dodd was making cars, Peter Vandenberge was making odd figurative pieces, Robert Arneson was making toilets and roses and bricks, and I was doing African animals and then frogs. We knew about Oldenburg and H.C. Westermann, but in Davis it was really just us, very provincial and yet reaching out—to the point that now even hobbyists do animals and flowers and electric irons and shoes.

I work every day at home in a converted garage with a color TV going on all the time, and with wife, four children, assistant, cats, punk rock, food, and cars around me. The cars are so I can go to Canada and the desert.

I am not a little person* like many sculptors who use clay. I am not a craftsman, except as much as any artist needs to be able to handle his material. I don't make pots, nor am I a ceramicist. I also like science-fiction first editions, cold weather, good cigars, hot weather, selling and trading things, watching samurai movies, and money.

The whole is me, humble David Gilhooly, born in Auburn, California, in 1943 on the anniversary of the end of the Spanish–American War. My work constantly deals with history and I have drawn from all my old childhood interests—acting, paleontology, anthropology, religions, literature, etc. These are the *real* sources of inspiration and influence. Fortunately I have never developed any real idiosyncrasies, such as turning squashed frogs into frisbees, writing fan letters to soap-opera stars, or eating organic food. I am, on that score, quite normal.

*This means I am not under 5'5". *Many* others are—no names need be mentioned.

40

My *favorite* pig piece is *Octapiss*—eight warthogs lined up at an outhouse. My favorite African piece is *Emma Hippo Memorial*—a life-sized teenage hippo in her own lily pads and frogs. My favorite moose piece is a copy of *Mickey Moose Comics*. My favorite beaver piece is *Beavers Carving Their Own Self-portraits* (I used to hire beavers to carve things for me at $10 an hour).

However, I knew I wanted to pick my favorite frog piece for this book, so I narrowed it down to four: *Frog Mountie Dropping His Cookies* (private collection), *Victoria* (Vancouver Art Gallery), the large *Frog Urn* (a continuous spiral of frogs turning themselves into urns; private collection), and this piece. Besides being one of the new outer-space pieces (including *Super Nova* and *Black Hole* [former in Crocker Art Gallery, Sacramento; latter in a Kansas City private collection] and *Robot Stellar Deli* in a Santa Barbara private collection), it is typical of the small, busy things that are my favorites because of their inti-macy, easy-to-packability, intense color and contrast, and sculptured movement frozen into one frame of a long story.

Here we see Frog Corbett and Robot attempting an earth reentry in their capsule while a group of demons armed with can openers, blowtorches, and pitchforks try to make it impossible. Where have they come from? What will happen to them? The viewer can answer these questions, though we are all sure Corbett will make it!

Most of my pieces like this one are illustrations of sagas or story lines, though the story does not come first but grows while or after doing the piece.

I love the apparent fluidity of the reds, oranges, and yellows. The immutable metal of the space capsule *does* seem to be breaking up. Will they make it in time? Tune in next week, same time, at my place!

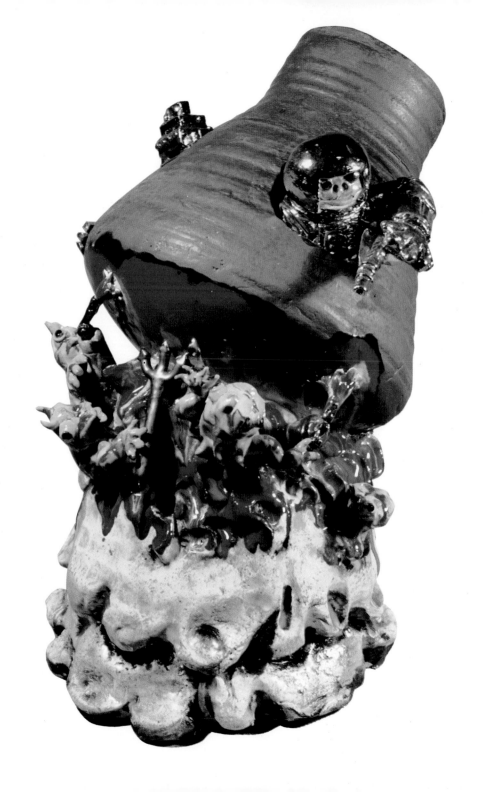

Dangerous Reentry • white earthenware with commercial glazes • 1981 • 21″ by 14″

Sidney Gordin

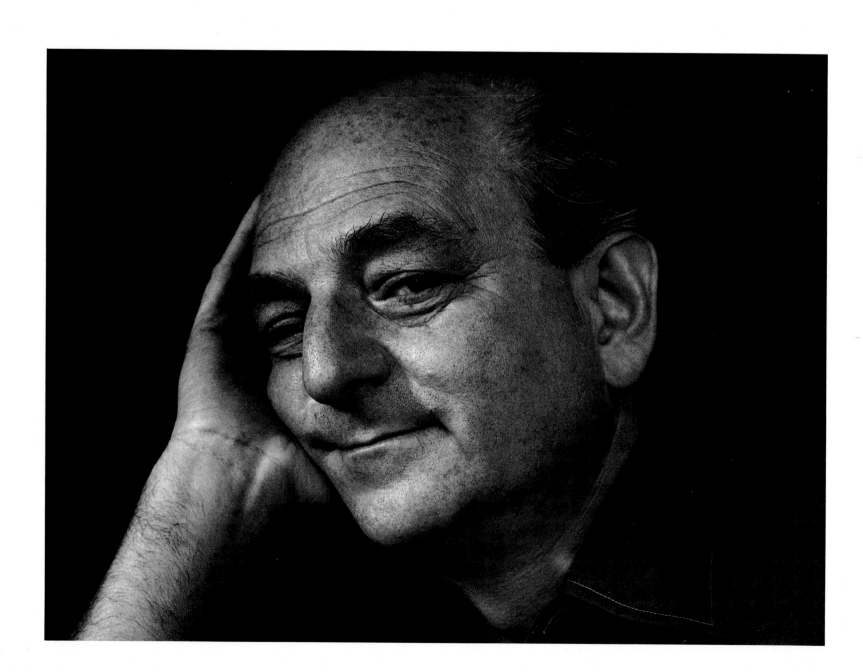

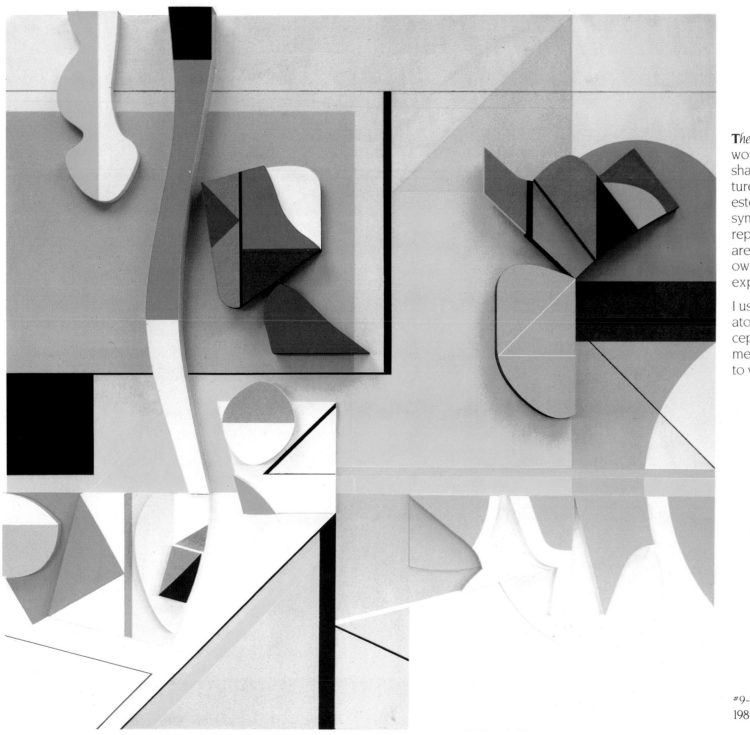

The subject matter for my work has always been form: shapes and colors structured in space. I am interested not in what they symbolize or evoke or represent, but what they are in themselves—their own poetry, music, aesthetic experience.

I use process as a collaborator and have devised conceptual methods that give me the maximum freedom to visually realize my ideas.

43

#9-80 · acrylic and wood
1980 · 4' by 4' by 3"

Tom Holland

My *mother* was a painter and my father was interested in nature and photography. I first went to Willamette University in Salem, Oregon, then to the University of California at the Berkeley and Santa Barbara campuses. The artist David Park has influenced me personally. Many others have influenced me through their work. I'm married and have three sons.

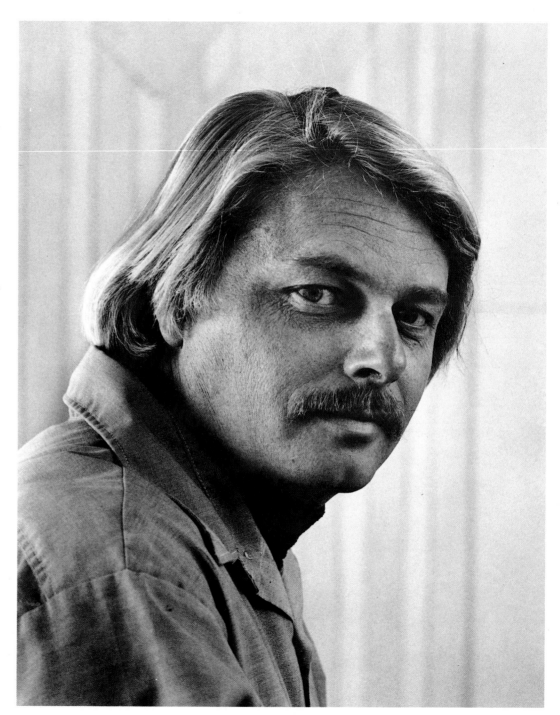

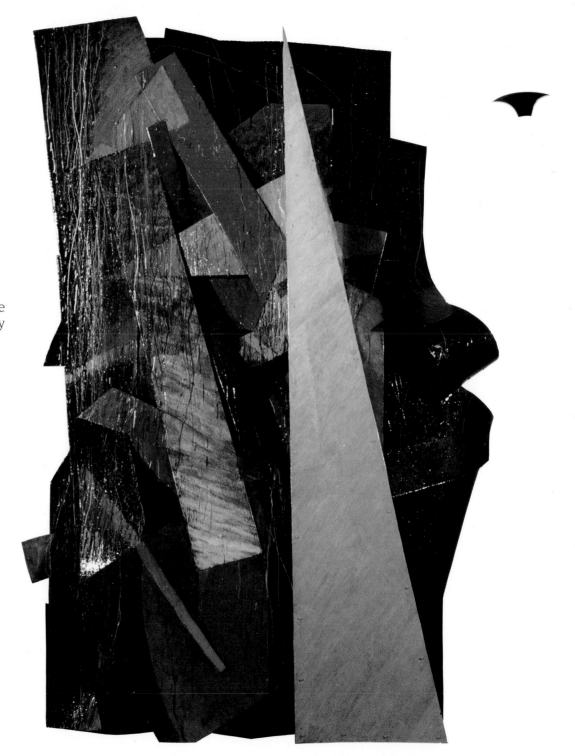

Helli is the largest piece I produced in 1980. I consider it and works like it to be paintings, even though they are freestanding. This is two-sided, as are most of my freestanding works.

Helli · epoxy on aluminium
1980 · 120″ by 79″ by 32″

Robert Hudson

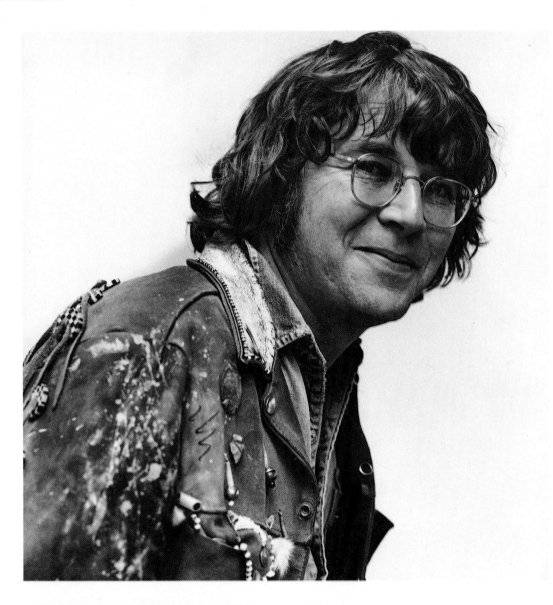

I *grew up* in Richland, Washington, near the Yakima Indian Reservation. As a kid I made drawings and paintings and carved totem poles. Bill Wiley, Bill Allan, and I all knew each other in Richland. A lot of energy for making art was generated from our friendships, which have now spanned thirty years. We had a high-school art teacher named Jim McGrath, who was a spiritual source for us. He had strong Native American ties. He taught us Indian art and culture, which continues to influence me.

After high school I went to the San Francisco Art Institute. Elmer Bischoff and Nathan Oliveira were among the teachers important to me there. The activities of the other students were critical in my development. I went to school with Joan Brown, Carlos Villa, Bill Wiley, Bill Allan, Jay DeFeo, Tom Holland, and Manuel Neri. Richard Shaw and Mike Henderson also came out of the Art Institute. Most of us still keep in touch.

I live in the country and like to fish and go out into the desert.

This work is a recent major piece. It was funded by a General Services Administration art-in-architecture grant for the Federal Building in Anchorage, Alaska. It is made of "flattened" welded aluminium cubes that give the illusion of four blocks set on pillars. Parts of them have been painted with acrylics.

Tlingit · aluminium with acrylic polychrome · 1980 · 16′4″ by 11′6″ by 6′

Richard McLean

I *grew up* in Kelso, Washington, and later in rural communities of western and central Idaho. From earliest memory, crayons and colored modeling clay were supplied me in quantity by my foster mother. My boyhood was dominated by a rich fantasy world nurtured by the certainty that miniature, pre-Tolkien elfin communities existed under the root systems of the Olympic Peninsula rain forest— a notion made all the more vivid by the book illustrations of H. Pyle, N.C. Wyeth, and Will Pogany. I learned anatomy and perspective from comic books and the Sunday funnies— that is, those artists who in the thirties and forties drew *Submariner, Captain America, Tarzan,* and my all-time favorite, Hal Foster's original *Prince Valiant*. Foster's historical authenticity and detailed drawing style taught me to appreciate the specific in the commonplace, the naked, unaltered *look* of things.

Later, as a student in the California College of Arts and Crafts in the late fifties, I learned to paint under two local but major influences: Richard Diebenkorn and Nathan Oliveira. Although our respective visions and styles are now very different, I like to think that the essential and enduring qualities of their sensibilities, those things I initially responded to, are still at work in my painting.

It's really true that I weep over Bobby Hackett records. If I weren't a painter I'd probably be a jazz musician. From the age of ten, when I got my first trumpet, I've nourished the fantasy of one day playing in a group. But the romance of music was always more attractive to me than the discipline, and that's why, at mid-life, the only gigs I get are three-minute snatches of Billie Holiday or Zoot Sims over my studio's FM. I keep a well-oiled cornet handy for such spontaneous occasions. They provide more than anything else a welcome break from the unrelenting tedium that in large measure attends the making of a painting.

Bourbon Jet is my most recent painting. I like it because it has all those necessary ingredients: bright California sunshine, strong value contrasts, informational complexity. I've always liked formal, aggressive imagery where the structure and organization are immediately apparent— easy access, no mysteries.

My interest in the horse and its related world of stables, people, and equipage grew out of my general inquiry in the mid-sixties into the possibility of animals as "suitable" subjects for painting (specifically my painting). I was between styles, you might say, at the time, and while realism as a practical and compelling solution to the problem of how to paint (see) was claiming my affections, the crucial question was *what* to paint. I was struck with the realization that the horse, that most ubiquitous and symbolic of animals in art, had been put out to pasture, as it were, with the advent of twentieth-century Modernism. Its utility was rendered obsolete and its mythic symbolism was an intellectual embarrassment. The prospect of a sympathetic rediscovery of this animal within the art of my own time was an exciting one. Could Rosa Bonheur find happiness with Andy Warhol?

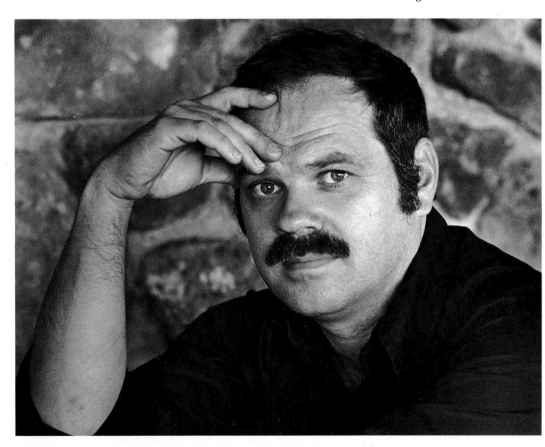

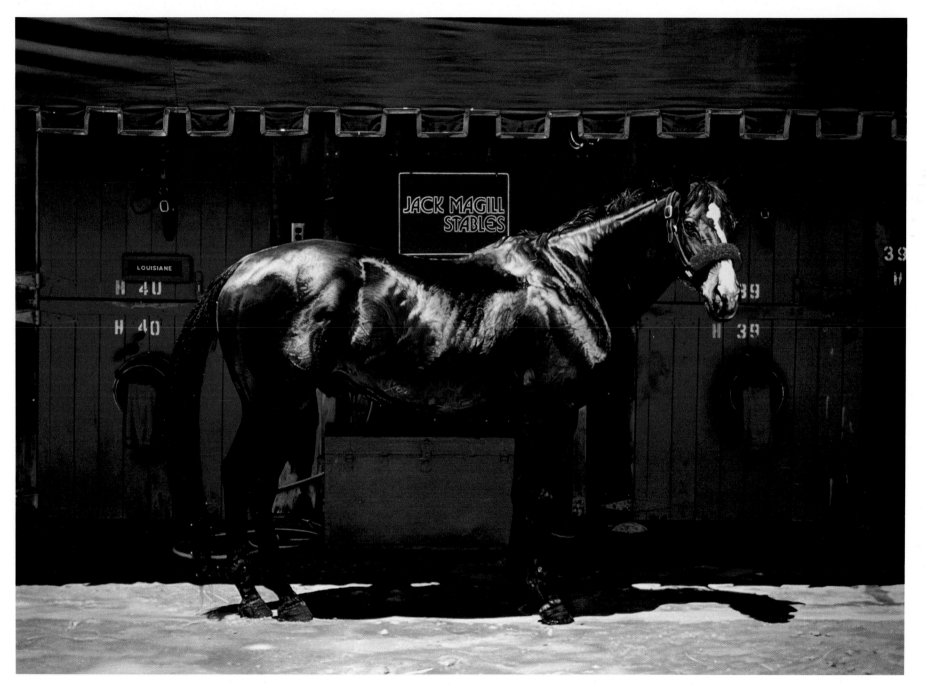

Jack MaGill's Bourbon Jet • oil on
canvas • 1981 • 50″ by 68″

Manuel Neri

Very early in my career, I began to paint on the sculpture I was creating. I relied on color to define and augment certain areas rather than relying solely on surface textures and contrasts. I applied enamel paint directly to the plaster. The effect was bright, shiny areas of color. The color was not an integral part of the form, but remained as an "indicator" which was used to draw attention to the sculptural shape.

Then for several years I stopped using color. I preferred the plain white of the plaster and the ways in which its surface could be manipulated by sawing, sanding, cutting, and chipping. With the plain plaster figures, my interest was focused on surface contrast and the ways in which this contrast helped to define the form through light and shadow. In 1977, I began a series of sculptures which explored gestural movement. This series culminated with my squatting/ seated figures and a return to the use of color.

Red Legs is from the series of squatting/seated figures and is perhaps the best example of the integration of surface texture, color, and form I

tried to achieve. The combination of surface treatments with form creates a visual tension that adds an additional element to the sculpture as a whole.

I have had several of my plaster figures cast in bronze. I have used color on the bronze and reworked the surface of the bronze after it has been cast. Of course, with bronze, the amount of reworking that is possible is limited and I have relied more on color to achieve the contrasts I had earlier achieved with surface textures. I have also been working in marble and treat it in much the same way as I treat plaster. The amount of physical effort to chip and break away the stone is enormous compared with working in plaster. However, the combination of surface textures and colors used to augment the sculptural form is much the same.

I have been working in Carrara, Italy, every summer for the past few years. I have

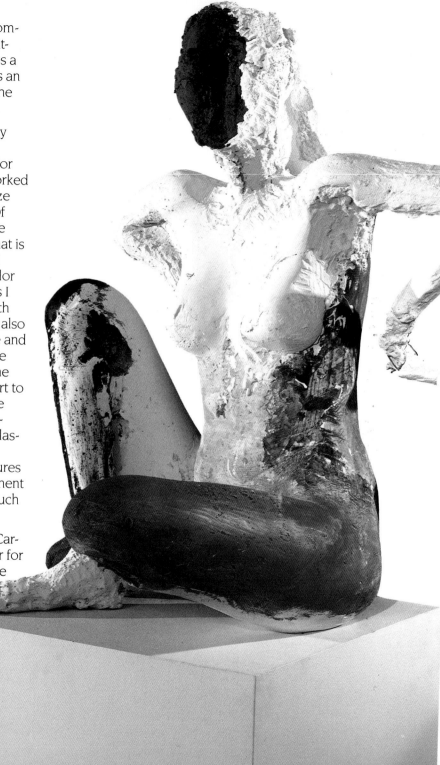

50

studio space and the tools I need to work with stone. Carrara is a very important place for me. There is that whole tradition of art that does not exist in the United States. Every morning I walk past the mail slot where Michelangelo mailed his letters. I look up at the same mountain of marble where he quarried his stone. Just looking at that mountain, which has been hacked at for centuries and is still immense, is a visual feast for me. There is no reason to be in Carrara unless you were born there or are working in stone. People from all over the world go there to work the marble. Artists are respected there. Life is less complicated. I am able to focus on my work without any distractions. If I need my tools reworked, there is a blacksmith shop. If I need a piece roughed out, there are craftsmen that can do it to my exact specifications. The marble itself is so lush and beautiful that I have to be continually aware of the danger of falling in love with that beauty. It is this opposite of the blankness of plaster that I find challenging and exciting.

Red Legs • plaster, dry pigment, steel armature, styrofoam core • 1979 • 33½″ by 33″ by 25″

I've always been interested in art. When I was very young I tried writing poetry. I was the only person I knew who preferred a French film with subtitles over an American movie. I liked carving pieces and knew at a very early age that art—all art—excited me. But I didn't know that I'd eventually be an artist supporting myself on art.

When I went to college, it wasn't like it is today. Sometimes I ate, sometimes I didn't. I lived in a van for a while. My mother helped me and I earned some money doing odd jobs. At that time it didn't matter, we were all poor and crazy about our art.

It was an exciting time in the Bay Area. Ginsberg read *Howl* for the first time. I ran the Six Gallery in North Beach. Janis Joplin was singing in small cafes in the same area. I'd been studying to be an engineer when I wound up in a ceramics class taught by Peter Voulkos. That was it! I never went back to engineering. The arts weren't separate like they are today. Poets, painters, and sculptors were all part of the same scene. I went to the Art Institute because I wanted to study with the people there and because it was in the same area where many of us lived, or at least tried to survive while we worked on our pieces. At night we hung out in the cafes and talked, exchanged ideas, listened to poets and singers, drank, and argued. It was great!

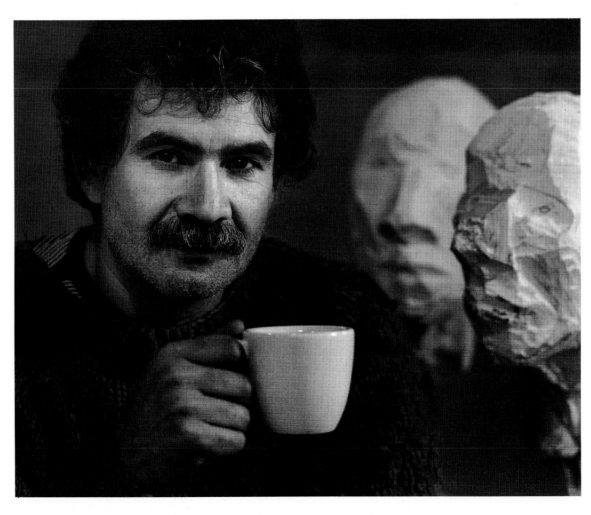

51

Nathan Oliveira

As with most children, I drew and continued through public school. Then I attended the California College of Arts and Crafts in Oakland until 1953. I also studied with Max Beckman at Mills College shortly before his death in 1950. This period of study was motivated by three major retrospectives at the M.H. de Young Memorial Museum: Beckman, Edvard Munch, and Oskar Kokoschka. The experience led me to become more interested in contemporary Europeans such as Giacometti, Picasso, Matisse, Marino Marini, and many others.

Not having total sympathy with the Abstract Expressionists, my association with those European figurative artists was essential, even though they were far distant from me in California. De Kooning's attempts to synthesize Abstract Expressionist language with figurative concepts were a logical continuation of my own attitude and formed the basis for my enthusiasm for the works of David Park, Elmer Bischoff, and Richard Diebenkorn in the mid-fifties.

I work on the Stanford University campus, where I live and teach. Though I have considerable interest in Europe and in traveling, I am most content with simply working and allowing the rest of a world that I am creating to unfold before my eyes.

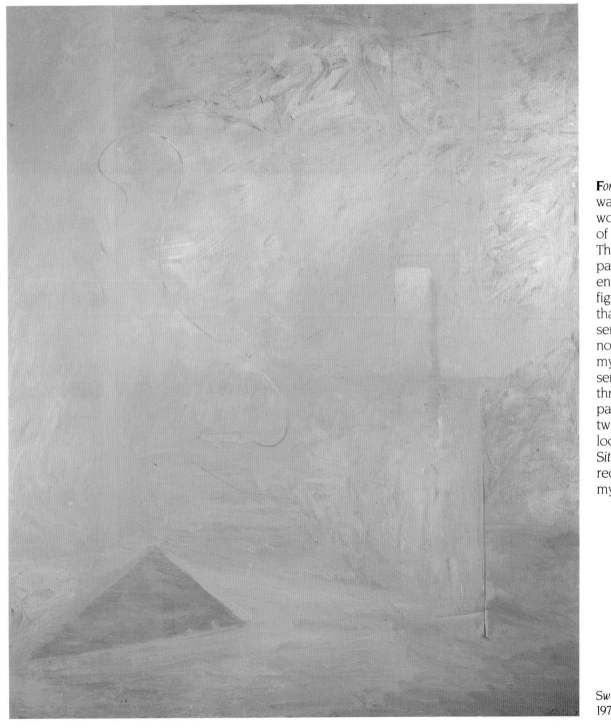

For *many years* the comment was made that my figurative work did not have a sense of place or environment. The *Site* series, whether painting or monotype, are environments with the figures removed. I hope that these paintings have a sense of landscape (luminosity, space) as much as my figure paintings have a sense of human presence through the gesture in paint. The hope is that the two concepts will merge. I look forward to this. *Swiss Site #6* represents the most recent development in my work.

53

Swiss Site #6 · oil on canvas
1979 · 96¼" by 77½"

Joseph Raffael

I *was born* in Brooklyn in 1933. I became interested in the arts in early life by experiencing the universe as expressed in nature. I began drawing and making pictures. A concept of "art" came later. I went to Cooper Union Art School and Yale University.

A*s long as* I can remember
and to this day,
seeing nature in its different
modes
has given me pleasure and
peace.
I paint of that luminous
experience
of seeing and feeling.
I like to think I paint feeling.
I am interested in spirit as
expressed
in nature, the invisible made
visible.
In California I have been
able to
expand my life and my
vision.

*Return to the Beginning: In
Memory of Ginger*
is a work of Spirit
manifesting through fish
and water,
through color and light.
It surprises me.
It shows me.
I thank it and I appreciate it.
It is an expression
of love and understanding
of the process of
life to life:
The everturningness of
nature within the universe.

54

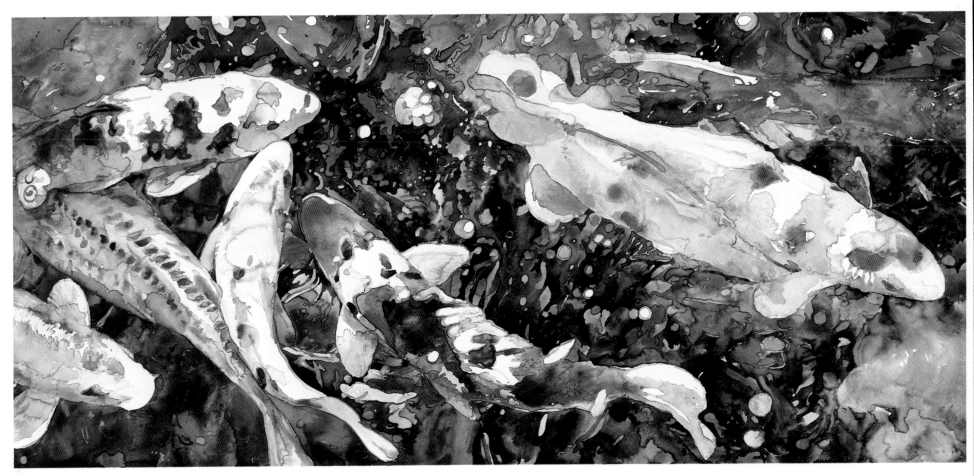

Return to the Beginning: In
Memory of Ginger · watercolor
1981 · 33½″ by 71″

Mel Ramos

I *have always* been influenced by people with original ideas—often by people with bad ideas, it is true, but never by people with no ideas. I'm interested, and influenced, by people who make art that gives us answers rather than raising questions.

I became interested in art in high school when I discovered the Surrealists. My interest has been steadily growing along those lines ever since. Currently I am preoccupied with the work of Immaculate Conceptualists, such as Morris Louis.

My wife Leta and I like to travel to Spain in the summer. For some curious reason that I have yet to figure out, Spain recharges my batteries. It lets me clarify and crystallize my thoughts. I always return to California with a tremendous need to work, which is my favorite way to pass the day. I try to work every day, even when I am not motivated. Ritual is very important to me.

This is my most recent painting, therefore my favorite. I've never been particularly excited about discussing earlier works. However, what I'm working on now and what I'm planning for the next work is another matter.

For several years my work dealt with the figure and the iconographic characteristics inherent in the figure. Now I'm getting away from that. My recent work is not figurative, but it is referential, and for many of the same reasons as with the figure, deals with the landscape.

Oakland, An Ode to Moe
watercolor · 1981 · 22″ by 30″

56

Fred Reichman

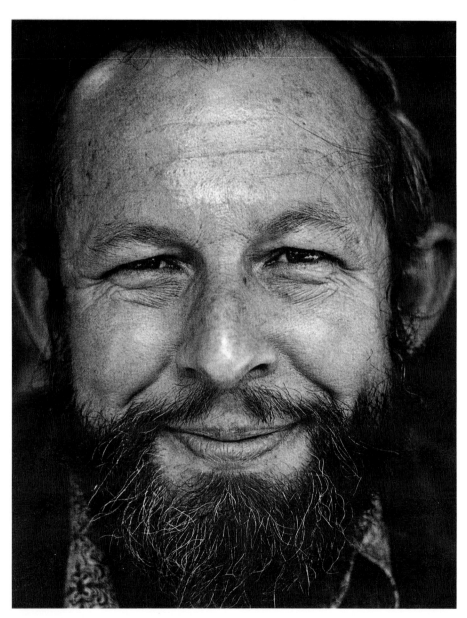

I *had decided* to become an artist when I was very young. My grandfather, James Yearing, lived in a cottage behind our San Francisco home. He was a carpenter by trade but a painter by avocation. There were always paintings on the walls.

Before I left for Europe in 1952 on a fellowship from the University of California at Berkeley, my art had been introspective, using only the imagination. When I returned home I wanted to involve myself with what I found and saw here, to go back to a more figurative statement, to sink my roots in a way that Cézanne had done in Aix-en-Provence. I discovered the landscape of Mt. Tamalpais, and many of my best paintings have come out of hiking in its environs. When I began to look at the landscape here, I discovered the work of the San Francisco painter Gottardo Piazzoni. He was— and is—a major source of inspiration.

There are two paintings I always return to for inspiration. One is El Greco's *St. John the Baptist* at the M.H. de Young Memorial Museum in San Francisco. The other is the Alberto Giacometti painting of a seated woman at the San Francisco Museum of Modern Art. I began a very influential friendship with Max Weber on my first visit to New York on my way to Europe in 1952; it continued until he died. On my way back from Europe, I met Mark Tobey in New York, who introduced me to the New York, Boston, and Washington, D.C., collections of oriental art. These had a profound effect on me. Weber and Tobey still interest me because of the spiritual and philosophical aspects of their painting. When you look at their work, you feel that they lived deep and satisfying lives that gave strength and conviction to their art.

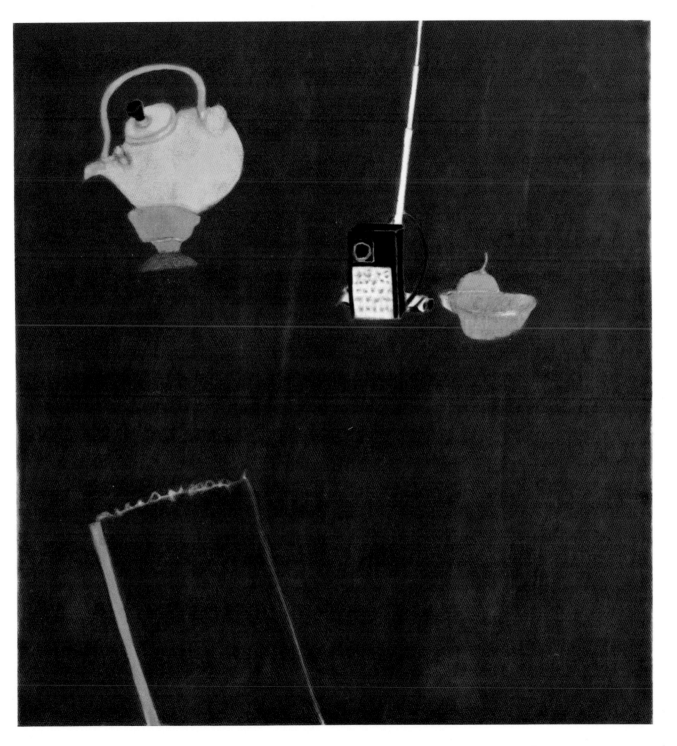

T*his is* one of the best of my recent works. It is still a surprise to me when I look at it. It has a one-gulp look that I like. The color challenges me. It is a fully saturated red—a red that has a particular weight and density that I would like to capture more frequently. And yet, since color to me is an expression of light, I always return to the idea of whiteness as my touchstone.

Its theme has to do with my daily activity, when I am alone with my thoughts and my works in progress in the studio that I have occupied for twenty-two years. The kettle in the painting is used for heating water and it ministers to the refreshment of my body, as the transistor radio ministers to the refreshment of my spirit. They wait for me and keep me company. They are part of the studio's landscape. This is all the more important because my studio is in the neighborhood where I grew up as a child.

In the Studio—Temporary Location
oil on canvas • 1979 • 48″ by 37″

Sam Richardson

I'*m a* landscape artist. But rather than simply recording the natural, I seek to use nature by taking the landscape as a visual theme within which to treat surfaces, make marks, paint colors, manipulate scale, and play shapes one on another. In terms of content,

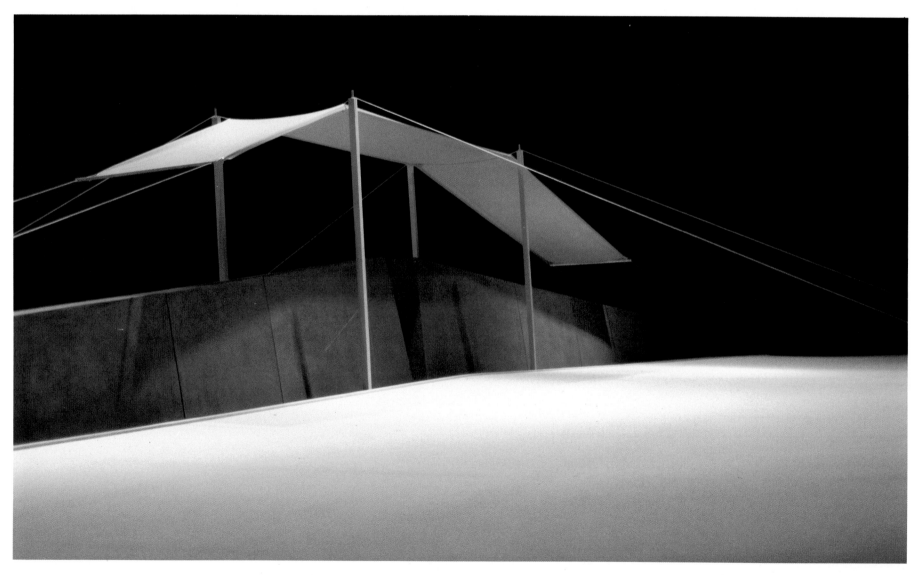

60

I take our universal relationship with the land—not to tell a story but to suggest a familiar experience, an illusion that will lead one to ponder rather than know.

This was an installation piece for the Santa Barbara Museum of Art. I chose the desert for imagery. As in all my work, the composition of the formal elements relates to the content of the piece. In this case the content has to do with the primary images of the desert and of archeology as they are played on by such secondary factors as heat, light, duration, activity, and the effects of these on the land. No piece is ever the total story; each is a part providing support to the cumulative statement of the series.

I am most satisfied with my work when the tension between simple reductive form and multifaceted content is balanced. Here, the formal elements—the wedge, pole, tent, and tent-line—are fused by shadow, color, line, and texture. I tried to create the sense of a familiar experience suspended in time.

Desert Image: Wedges/Area 5
wood, cloth, rope, and paper
1981 · 6½' by 40' by 19'

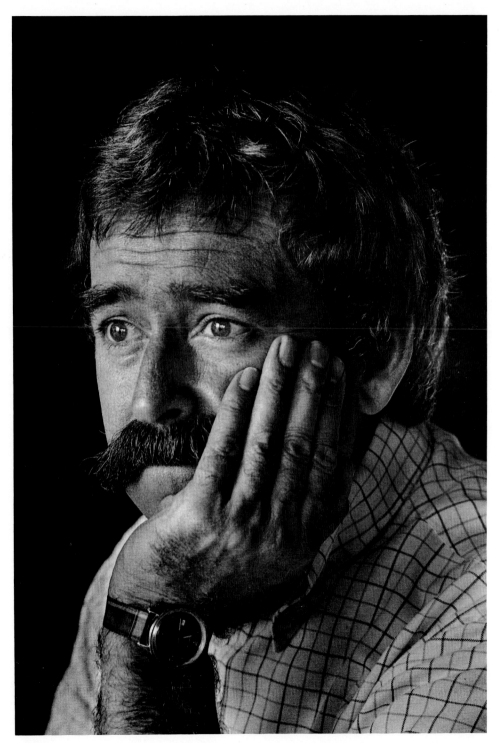

With *one thing* leading to another, the cardboard toy constructions of my childhood led me along paths of invention and experiment to the California College of Arts and Crafts in Oakland. Shortly after I finished there, I went to New York. It was a real eye-opener, a whole new exposure to the arts. When I returned I had a fresh perspective. I found myself very influenced by the surrounding landscape—an influence that has contributed greatly to my thinking and work.

I like to work where we live in Oakland. I get a lot of support from my wife Adrienne and from our children. It is a family not merely interested in my work but one that provides the environment in which I can continue to invent. My studio assistants also have played a strong supportive role in the realization of my work. Away from the studio, I enjoy a sunny afternoon at the ball park or a starlit night around an open campfire.

Raymond Saunders

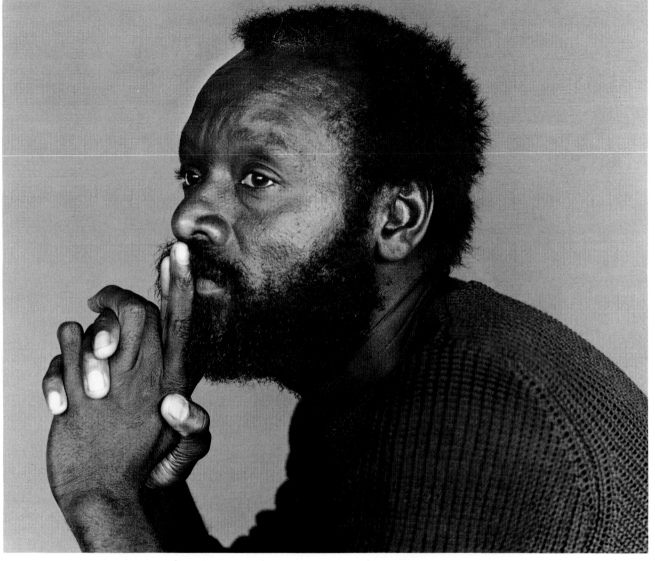

I *was born* in Pittsburgh, Pennsylvania, in 1934 and became interested in the arts in the first grade. I got my bachelor of fine arts degree at Pittsburgh's Carnegie Institute of Technology in 1960, then came to the California College of Arts and Crafts in Oakland, where I got my master's degree in 1961.

Although there have been many personal influences before and since, I should note two people never before mentioned: Sigfried Gideon and his wife Carola Gideon-Welker. Both were good friends of Paul Klee. They visited my studio one day just as I was preparing to send out an exhibition. I was complaining about the time it took to title the works and said that I was just going to number the images. But Carola, who had written several books on Klee, brought it to my attention that Klee thought it important to expend that kind of energy.

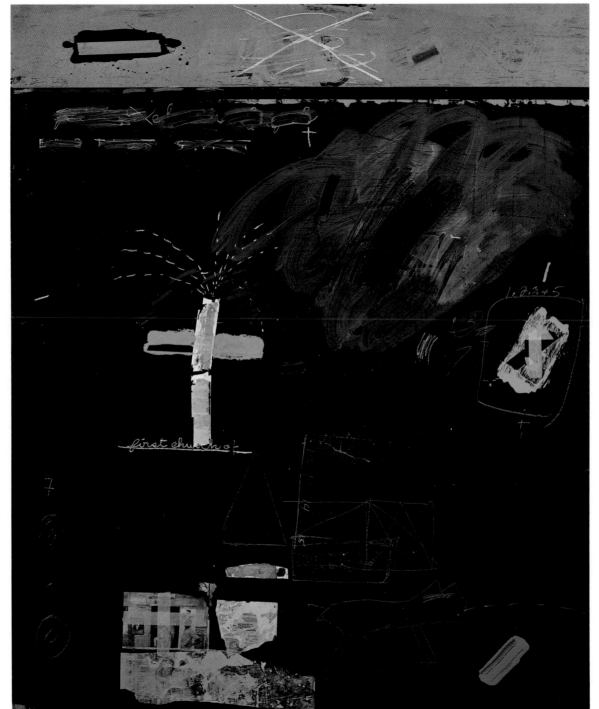

Why did I choose *1,2,3,4,5* for this book? Who knows? I don't! It's recent, it's old, it's ongoing. Why does one ever choose? Definitive? Never. Maybe only death is definitive—and then maybe not!

1,2,3,4,5 • oil on canvas • 1974 • 86½" by 68¾"

63

Richard Shaw

I'm interested in why all kinds of people make things, the materials that they use, and what their work tells about them. A person consciously or unconsciously arranges things like cigarette butts, broken matches, and glass coasters after a dinner, then leaves his place different from the place of the next person. These leftovers tell an incomplete story. I'm fascinated with the questions raised as much as with the objects used.

I like illusion, whether two-dimensional or in the round. Limiting myself to a particular material such as porcelain and making something out of it that looks like another material

has a magic that I like. Building a figure out of cast and sculptured junk lets me say how I feel about people, recycled trash, movement, humor, clay, and so on, all of which I think are beautiful.

Melodious Double Stops glazed porcelain with low-fire transfers • 1979 • 38¾" by 12" by 14"

My father was working at the Walt Disney studios when I was born in 1941. Both my parents were artists and had come West just before the war. All their friends were artists, cartoonists, and writers. I spent my youth drawing train wrecks, battles, and maritime disasters.

In 1950 we moved to Newport Beach, California. At high-school age I was painting and making movies—in fact, that's all I was doing. I was so bad academically that I was sent to boarding school, where I learned to play music, wrote a mountain of poetry that now gives me sweaty palms, and discovered that what I really wanted to be was a fine artist.

I majored in art in junior college and met Martha, who is now my wife. After seeing the work of Bischoff,

Diebenkorn, and Oliveira, we moved to the Bay Area to attend the San Francisco Art Institute. Somehow I missed taking any classes from these artists and ended up working in ceramic sculpture. Clay was attracting more and more attention in the art scene and the ceramics department there was exciting. I studied with Ron Nagle, Robert Hudson, and Manuel Neri. Then I went to the University of California at Davis and studied with William Wiley, Robert Arneson, and Roy De Forest. These artists, the atmosphere, and the times, plus some good luck and my own excitement, all combined to push me towards being an artist.

I've been teaching at the San Francisco Art Institute since 1966 and working in various seedy studios. *Melodious Doublestops* represents the kind of work I've been doing since 1978.

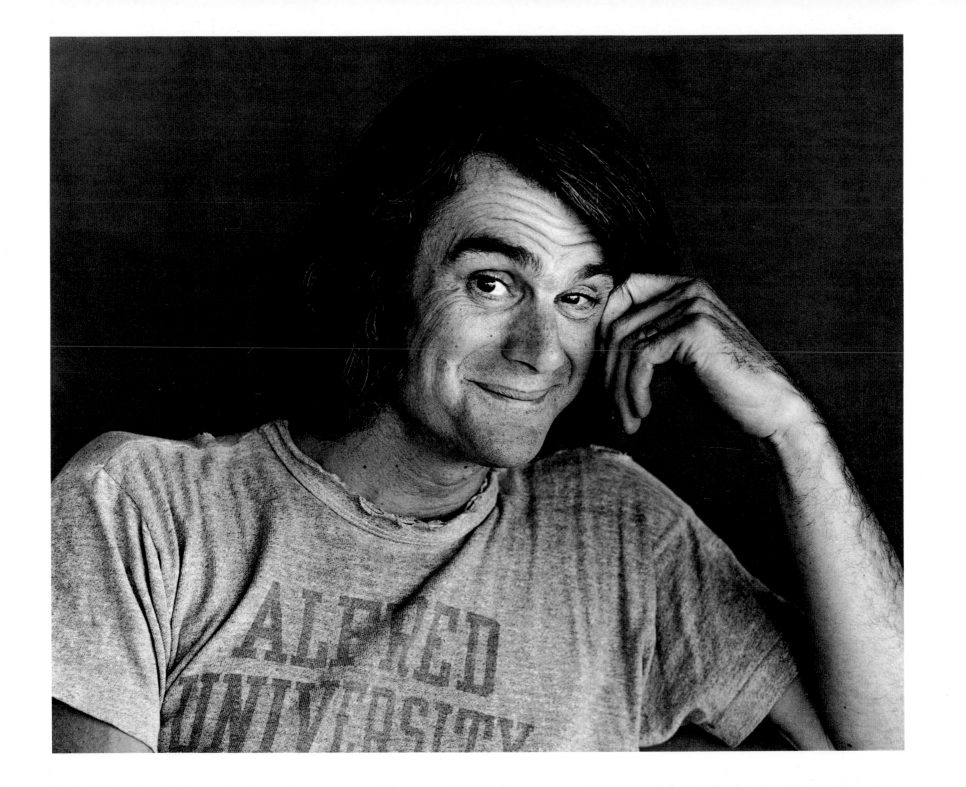

Louis Siegriest

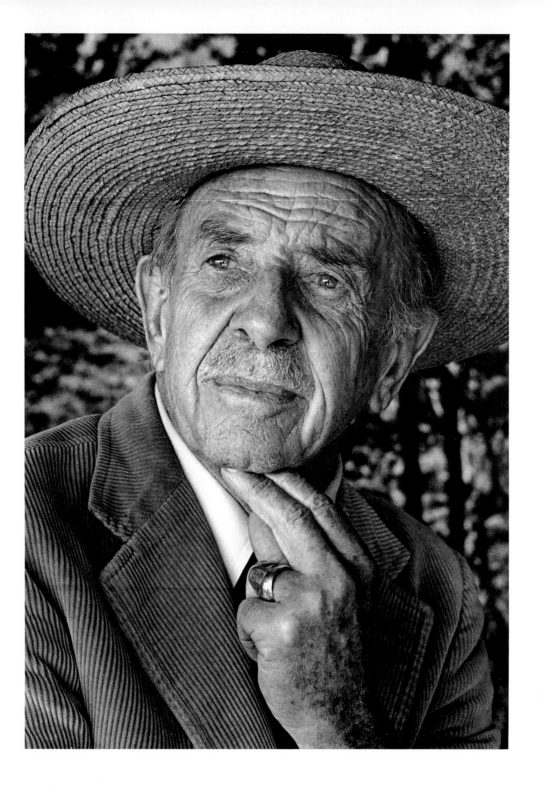

I *was born* in Oakland in 1899. My mother liked to draw and encouraged my interest in art. When I was in grammar school, I won an art contest sponsored by Bud Fisher, who did the nationally syndicated Mutt and Jeff comic strip for the *San Francisco Chronicle*. Everybody encouraged me to attend the California College of Arts and Crafts in Oakland. Then I studied at the Van Sloun School of Art.

When I was young, Selden Gile, who was the leader of a group of painters called The Society of Six, invited me to paint with him and be a member of the group. The influence of these outdoors painters has remained with me to the present. Other artists I especially admire are Ignacio Zuloaga, Morandi, and Goya.

I work in an outdoor studio. I place the paintings on low benches and paint from memory in the open. I have always felt more natural working out of doors. I never make sketches or studies when traveling, but think a good deal about the landscapes I have seen and then begin to work. I do all my work from generalized impressions formed during and after these trips.

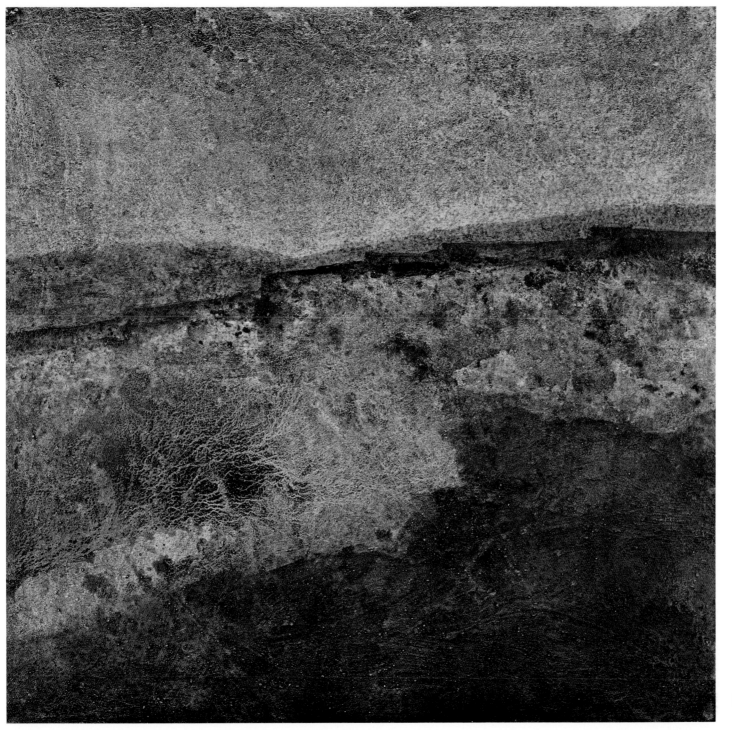

I*'ve always* been interested in the spectacular terrain of the deserts of the West, especially the magnitude of their cliffs.

I work with heavily textured surfaces and broadly conceived imagery to capture generalized impressions of the vast forces and dimensions of the desert's often overwhelming subject matter. These works develop in my studio after periodic trips to the deserts of Nevada, California, Mexico, and Utah. The surfaces of these paintings are freely manipulated—I gouge them here and scrape them there, while working with gypsum (the actual material of the desert) and polyvinyl glue to get the subtlety of the earth tones and hues I have observed.

However, in order for these paintings to be successful, they have to be read well at a distance. While stepping backward, the observer must be able to see the various shapes and forms pull together so the paintings will read as landscapes. Some are more generalized than others, but they all share a definite landscape identity.

Desert Lake • mixed media • 1973 • 48″ by 48″

Wayne Thiebaud

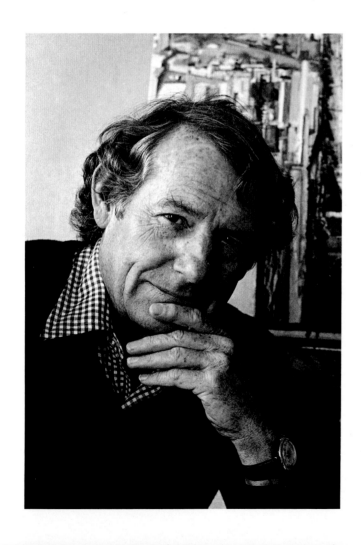

Very *little* has been written about the way painters—as opposed to critics—think about realism. We tend to think of realist painting as an accurate replication of reality. But reality is just a method of interpreting our perceptions. Even photography, which is considered a documentation of reality, is actually a lyrical interpretation of our world.

For me, realist painting is very different from photography. It is a multifaceted confrontation with subject matter caused by the variability that exists within the perceptual experience. If you stare at an object, as you do when you paint, there is no point at which you stop learning things about it. If you genuinely are a realist painter, you finally realize that what you are doing is a tremendous amount of adoption, adaption, and change. What's vexing is that there's no answer that defines realism.

Velázquez, Vermeer, Chardin, and Thomas Eakins—as sweeping examples—are artists who needed to have objects before them all the time as a primary requirement for the painting to come into being. Their perceptions were always a direct result of looking at the object and attempting to find out as much about it as they could —not just in terms of their perception, because there's no end to that, but in terms of the abbreviation that becomes what we call a realist painting. They effectively totalize and make coherent a visual moment in time.

What is surprising is that if you are told how the paintings were supposed to be developed and you remove your mind for a moment from the actual painting, you would assume that the paintings by these great painters would be very similar. Indeed they are, but at the same time they are also tremendously different. You can cut a quarter-inch square out of a piece of paper, put it over a Vermeer, and still know immediately that the painting is a Vermeer. You can do the same with Chardin, Eakins, and so on. What fascinates me is what makes those paintings so different. What is there, given that they all have similar sets of concerns and are continuously using perceptual confrontation, that allows for this kind of variety?

One characteristic would be the way each painter

uses time—whether it is expanded, contracted, layered, or condensed—which distinguishes between staring and glancing. For example, the paintings of Frans Hals are candid, a quick glance. By comparison, Rembrandt's are reflective, quiet, staid, timeless. With Hals, time is abbreviated; with Rembrandt, it is expanded.

The same idea needs to be explored in the same way with notions of space, light, design, etc. The difference between Hals and Rembrandt with respect to time is but a single aspect of a complicated study that could, with reflection, reveal interesting questions about the complex analysis of realism.

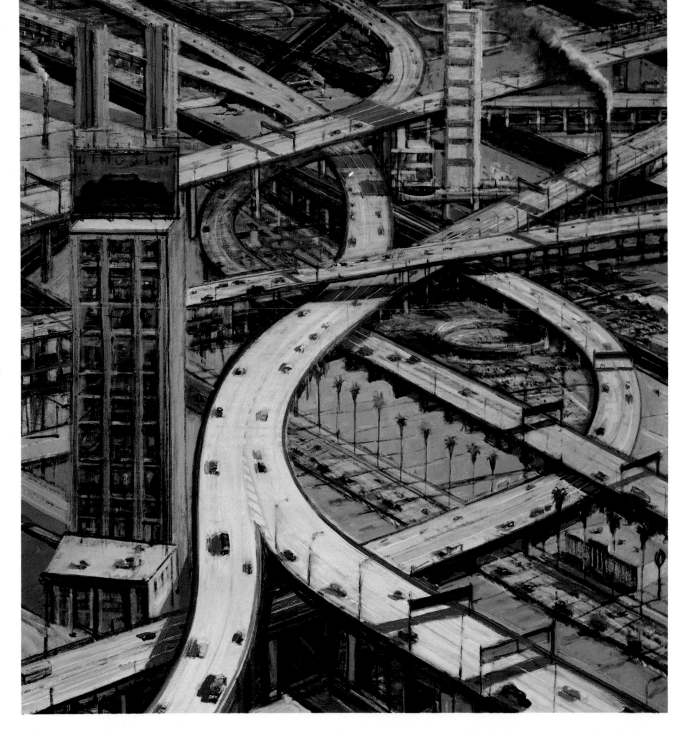

Urban Freeways • oil on canvas
1981 • 48″ by 36″

69

Leo Valledor

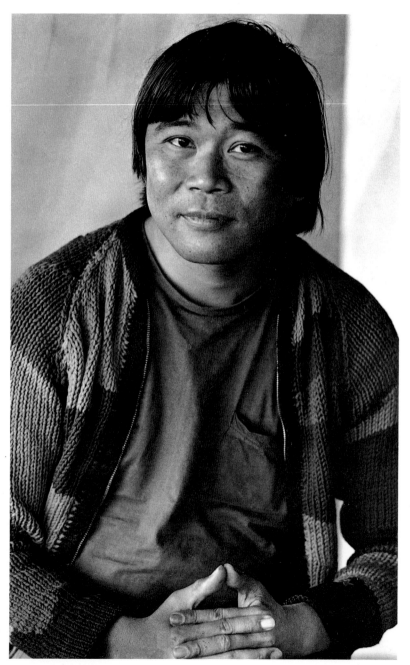

I*'m a native* San Franciscan, born in 1936. My interest in art goes back as far as I can remember, and I loved to draw even before that. I used to visit the San Francisco Museum of Art often. It was in my neighborhood and offered free admission into its fascinating world. I painted my first serious oils in 1953 when I received a scholarship to the California School of Fine Arts. They were "expressionist" abstractions. The Six group and their gallery invited me to join them and I was able to exhibit my *Compositions* and *Jazzus* series. During that time I met many artists who left lasting impressions on me.

After the exhibition of my B*lack and* B*lue* series at the Dilexi Gallery toward the end of the fifties, I made shaped drawings and then caught a plane to New York in 1961. A few artists there were friends of mine from San Francisco and some of us joined together with others to form the Park Palace Group and its gallery. My main interest was color and a switch to acrylic polymer. Abstract Expressionism became Hard Edge.

I returned to San Francisco in 1968 and immediately began my E*ast–*W*est* series, which was exhibited at the San Francisco Museum of Art and the San Francisco Art Institute. In 1972 I began to paint large, shaped, multi-panel color fields; this continues into the present.

This is a somewhat eccentric painting by me since most of my recent pieces are large, shaped canvases. I especially like the color, which of course cannot be separated from its form except by words. This painting works for me because it stirs my feelings of warmth and delight, of hope and the heights, of joy and love. It embodies the things that inspired its making. It is the sparkle of my spirit.

SFUNRI • acrylic on canvas • 1981 • 4′ by 3′

Peter Voulkos

I *was born* in Bozeman, Montana, in 1924. My parents were Greek. I went to Montana State University under the G.I. Bill and decided to get a degree in art. I first worked with painting, in which I developed a strong interest. Then I took a course in ceramics and fell completely in love with clay. My energy was drained from painting and I couldn't concentrate on it any longer. The work in clay took everything I had.

I got a bachelor's degree at Montana State and then attended the California College of Arts and Crafts in Oakland for graduate work. When I came to teach at the University of California in Berkeley, a few others and I started making small metal sculptures that eventually became larger and larger environmental pieces.

I've been influenced by the Abstract Expressionists of the late forties and fifties. While I was in Los Angeles I studied guitar and became interested in musicians, writers, and poets, but basically painters.

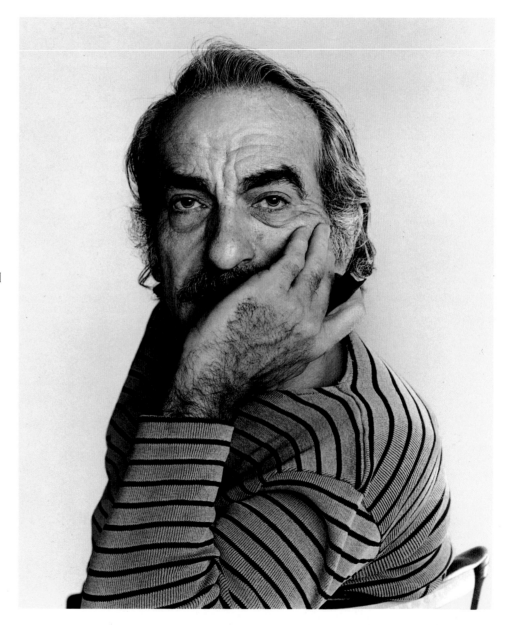

72

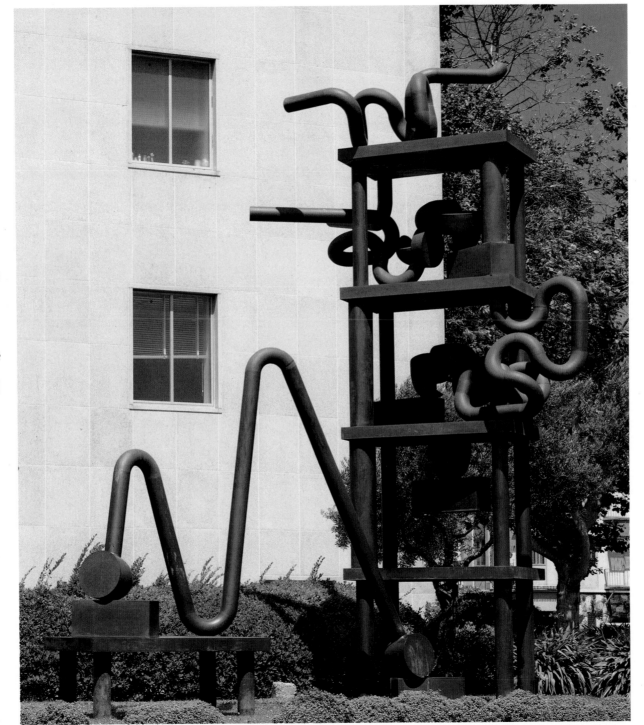

The commissioned work for the San Francisco Hall of Justice is my most ambitious work. The more I look at it, the more I like it. I go out to look at it frequently—in moonlight, in the rain, in the fog, and all times of night and day. It tells me a lot and asks me a lot. Each time I look at it it offers me something I haven't seen before.

Untitled · bronze · 1968–1971
30′ by 22′

William Wiley

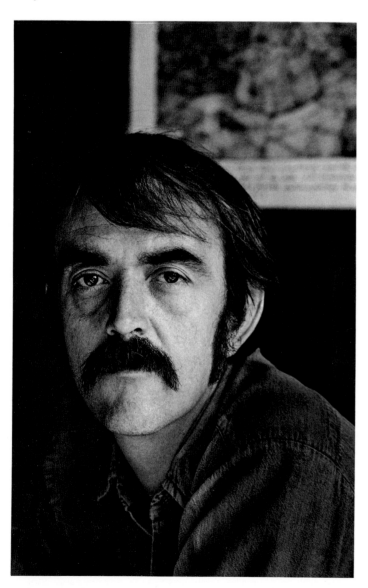

Inscribed on the tombstone of a Chinese monk—via a photo via a friend: "There is no time. What is memory?"

I've been interested in drawing and painting as long as I can remember. Happily for me when I was growing up, it wasn't discouraged. I was born in Bedford, Indiana, and left with my parents and younger brother when I was ten. Moved to Washington state: Richland, in the southeast corner: plutonium plants, atomic frontier days. Dad worked on construction and we lived in a twenty-five-foot house trailer. We moved, traveled through the South and Midwest, settled in Texas near Dallas, and traded the house trailer in on two house cats and a filling station on two acres with a peach orchard. Next summer we sold it and moved

on, back through the Midwest, south to Florida, back, stopped in California that fall. Next summer, after a little more rambling, moved back to Washington, North Richland this time, then West Richland and a house on the Yakima River.

Two important teachers there: Thelma Pearson in junior high, a good teacher who gave strong encouragement; then had two years of very important and strong encouragement from James McGrath. He helped me organize the heart and spirit—and a portfolio that got me a scholarship to the San Francisco Art Institute.

All those travels, landscapes, cafes, signs, words, thoughts, accents blowing from coast to coast! Me and Chuck taking turns on a harmonica till we got pooped, and out of boredom making paper and cardboard cowboys and Indians, Western towns, guns, special effects, nice details. Stuffed into the cracks in the back seat, where long plays and

dramas took place, people fought and died, got hung, torn in half, crayoned and penciled to pieces. Soaking up all that stuff, finding freedom in a car traveling all over the planet, in the summertime when you could have been swimming or playing ball with your last set of pals. Art! What a concept! It saved my life! A place where you can do as you please!

Good contacts continued with the teachers and students at the Art Institute. Got very fortunate at that time, married Dorothy Dowis. More good stuff: sons Nathan and Zane. Lots of love and help from them. Mom, Dad, family, plains, planet, people hearts and magic, all drawn from by some visible/invisible source. Guess that ought to do it!

I *wanted this* to be in the book because:

1. I have dreams and illusions of being the one in charge.
2. It is recent.
3. Colorful.
4. Shows both painting and drawing.
5. Modest in scale.
6. Based on an actual event.
7. I like it.
8. e = Tut Tut, or, energy seems to hold all statements true as well as untrue.

I *Visit Bob* · acrylic and charcoal · 1981 · 44½″ by 47½″

Paul Wonner

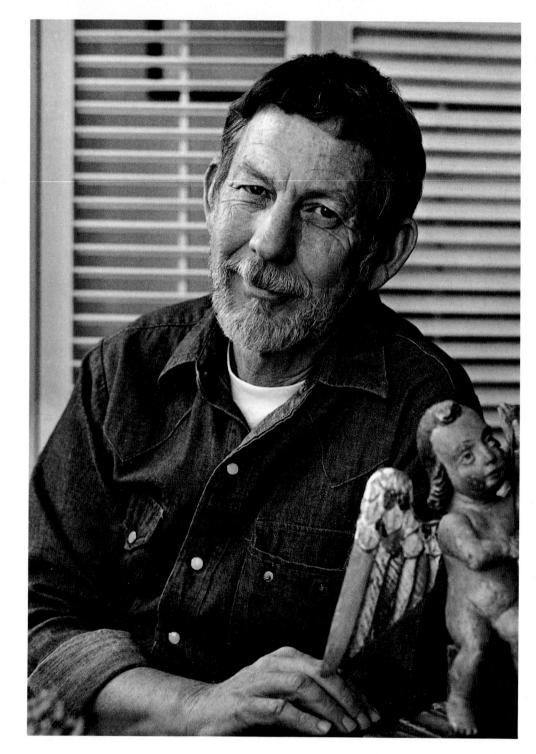

How did I get interested in art? I've never been otherwise!

76

To me *this seems* representative of my current work, which grows out of my interest and pleasure in seventeenth-century Dutch still-life paintings. I wanted to paint some of my own.

My method is to first set a background and a "floor" plane, then paint the objects separately, one by one, not arranged ahead of time. I seldom know what will come next, and the final result is always somewhat of a surprise to me. I try to bring everything together by subjective linear designs, each object or shadow leading to another throughout the painting. Drawing and perspective are altered to support the linear composition. Objects usually do not overlap; each is to be seen as much alone as in context with others. They are painted approximately life-sized and are selected at random from things around the house that I'm familiar with and like or commercial products that I use frequently whose packaging or design interests me.

"Dutch" Still Life with Lemon Tart and Calendar • acrylic on canvas • 1979 • 47¾" by 96"

SOUTHERN CALIFORNIA

Art in Southern California is still in the process of establishing its own traditions, since there is no long heritage to look back upon for nourishment or rejection. Prior to the 1920s only a few artists were there, painting the rolling hills, the eucalyptus trees, and the ocean in less than inspiring fashion. Then, almost overnight, expatriates returned and European-trained artists moved to the area. Clear signals began to appear that Los Angeles was on the move. ⟨ Stanton MacDonald-Wright returned from Europe after achieving an international reputation as a co-founder of Synchromism. Lorser Feitelson, freshly full of the knowledge of Cubism and Futurism, moved West. The growing international character of the Hollywood film industry brought artists such as Man Ray and Oskar Fischinger. In short, the beginning of a Southern California art sensibility was imported and international, with an emphasis on abstract ideas. While one cannot make a one-on-one point of direct influence, this attitude remains the mainstream up to the present time.

Charles Arnoldi

I *have become* interested in wood as an alternative to painting. I especially like tree branches, which have a very distinct line quality. They feel hand-drawn, they have a certain gestural quality, a naturalness. They feel seductive. At the same time I recognize that my work demands to be part of a well-defined pictorial tradition. *Volcano–Log Jam*, in combining different kinds of information, represents a synthesis of these concerns. It provides a solution to my desire for subject matter, enabling the work to be distinguised from the cold, meaningless—albeit beautiful—object.

Volcano–Log Jam • wood and oil on canvas • 1980 • 84" by 144"

I *was born* in Dayton, Ohio, in 1946 and grew up in various residential neighborhoods. It was not an artistic environment. When I graduated from high school in 1964 I moved to Los Angeles and, except for a year in New York in 1971, have lived there ever since.

After a year of odd jobs in California, I ended up in Ventura Junior College and found for the first time that one could actually study art in school, with the immediate goal being acceptance to the Art Center School in Los Angeles and the goal beyond that a job in commercial art illustration. I was directed toward a career in commercial art illustration. I was accepted by the Art Center, but before I enrolled I took a trip to New York. There I saw Klines, De Koonings, and Rauschenbergs, and was overwhelmed by their size and handmade quality. Art was not like the slick magazine pages, it was a human activity. I realized that painting was my true interest, not illustration.

I came back to the Art Center and lasted two weeks. I transferred to Chouinard Art Institute, where I stayed about nine months. I met other people with whom I could exchange ideas and who were more interested in pursuing a life of art rather than a career of illustration. At the same time I also came to realize that discipline and hard work were the key elements in an artist's life. I felt that the studio took the place of the school, and I quit.

Now I work every day, all day long and sometimes into the night in the studio. I've been doing it for years and it only gets better.

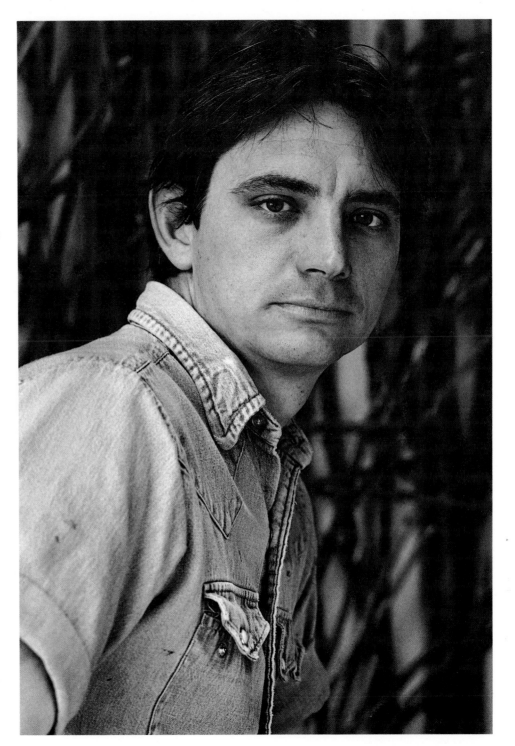

Tony Berlant

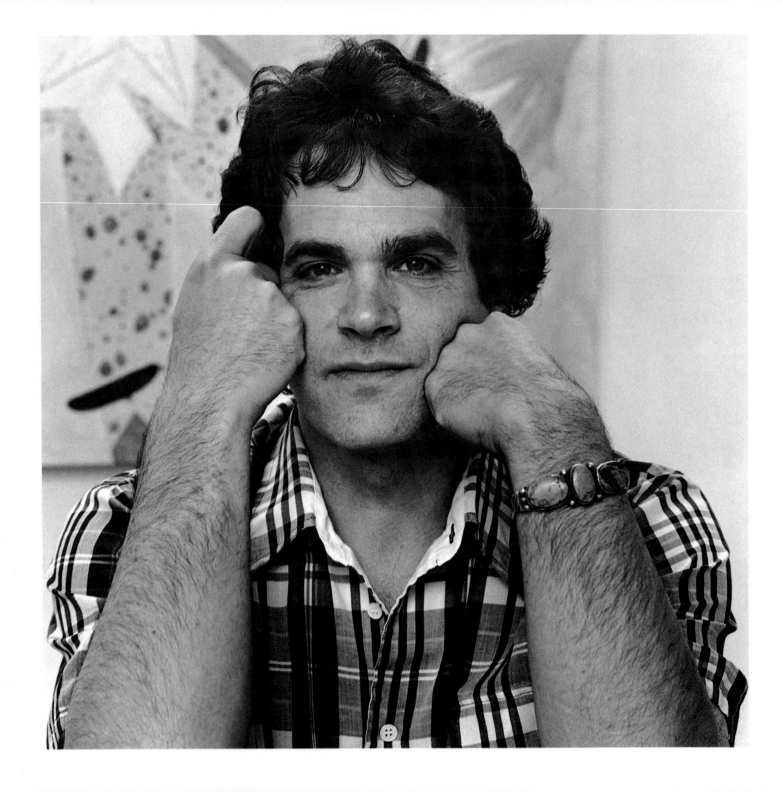

The Mesa · metal collage over plywood frame · 1980 · 54¼" by 54¼"

William Brice

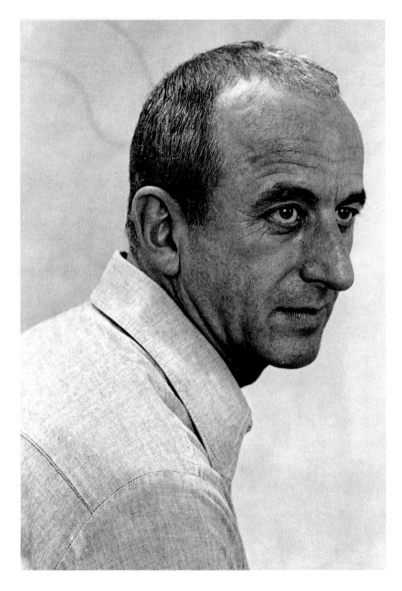

I *was born* in 1921 in New York City. My mother was prominent in the theater and I was privileged at an early age to become acquainted with the world of the New York theater and to meet actors, writers, and artists. At fourteen I began formal studies of drawing and painting with Henry Botkin, and I became familiar with the diverse works in the New York museums and with the contemporary art of the New York galleries. By the time I was sixteen I was absorbed in the fascination of the arts and I sensed in the process of drawing and painting that I had found my vocation. In 1937 my family moved to Los Angeles and I began to attend classes at Chouinard Art Institute in Los Angeles.

Herbert Jepson, Henry Lee McFee, and Francis Murphy contributed significantly to my education there.

Following my service in the U.S. Air Force I began to work independently in Los Angeles. Since that time I have intermittently returned to New York but have lived and worked in Los Angeles.

Several trips to Mexico and extended visits in Europe have been especially valuable to me. I consider two trips to Greece and the Aegean Islands during the seventies to have been particularly stimulating and influential. An emerging direction in my painting prompted the journeys to Greece. The experience of Greek art in the environment of its origin and the experience of the miraculous transformative phenomena of the Aegean continue to affect my current painting.

This *work involves* formal considerations which continue to be of interest to me: a juxtaposition of differentiated elements that involve line, shape, form, value, color, and substance in a spatial interaction that establishes a tension and equilibrium. Over the last ten years I have become increasingly concerned with the interrelation of formal values and associative qualities. The human figure and forms in nature predominate as a source of reference, and my work tends toward an imagery of fragments. I believe that the associative resonance inherent in visual symbols can be limited by literary assignation and consequently I do not title these paintings.

Untitled · oil on canvas · 1978
114″ by 143″

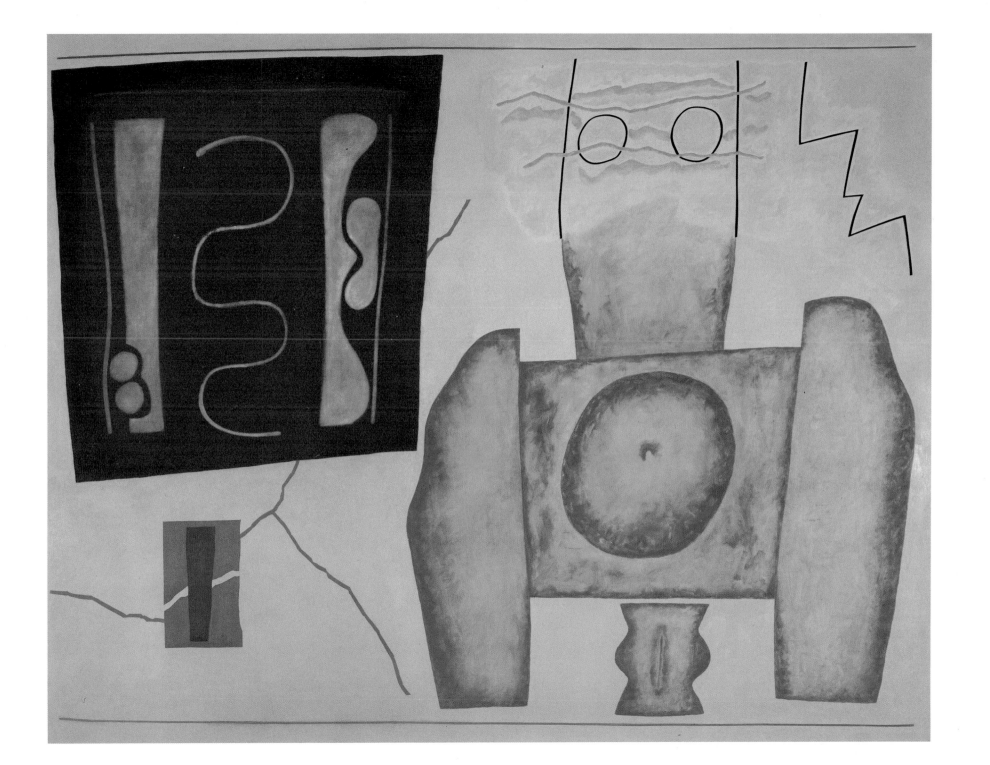

Vija Celmins

I *can't remember* a specific beginning to my wanting to make art. It seems to have been a natural, inherent tendency. I was born in Riga, Latvia, and arrived in the United States at the age of ten. My family settled in Indiana, where I lived until 1962, when I graduated from John Herron Art Institute in Indianapolis with a bachelor of fine arts in painting. I then moved to Los Angeles, a place I imagined to be an open, exotic, tropical city full of artists and intellectual adventures. Once there, however, I retreated to a large cavelike storefront that I found in Venice and there proceeded to try to come to terms with making paintings. I also received a master of fine arts from UCLA.

Although I found my impressions of California stimulating, most of the adventures occurred for me in the studio. My childhood had been rich and varied in events and perceptions, and I found this a great resource. Sometimes I would long to capture some remembered light or feeling from my earliest years. The studio became a place for me to reimagine the world in terms of art. I found it hard to do and have always had great anxiety about making art. I think this anxiety also remains in my work in the form of tension —tension between surface and depth, movement and stillness. This has probably become my constant subject, finding the place where these things are in balance or can exist without me. In this pursuit I have included images from the place I live —my studio, objects around me, and the landscape of the area. I have also had help from other artists, my peers, and predecessors, to whom I look for inspiration and insight.

Untitled · graphite on acrylic ground on paper · 1971
14″ by 19″

In this work there is a tension between a tight, unified surface and an illusionistic, engaging deep space. I like it because there is a nice tug between the two. The work is singular, clear, and strong, yet has some aspects of emotion, softness, and refinement. It is an example of a long-time preoccupation I have had with the balance between abstraction and the recognizable image.

Judy Chicago

I *started talking* late—when I was two and a half years old. There was a lot of pressure in my family to talk, as everyone was very verbal. Six months after I started talking, I began drawing. Almost forty years later, I'd still rather draw than talk.

My life is basically simple. I run every morning, work all day, like to eat cookies, and hate to talk or answer the telephone almost as much as I hate to be interrupted when I'm working.

I went to the Chicago Art Institute and have been influenced by the work of Georgia O'Keeffe, Emily Carr, and Anaïs Nin.

The Dinner Party · mixed media · 1974–1979 · 48' by 48' by 48'

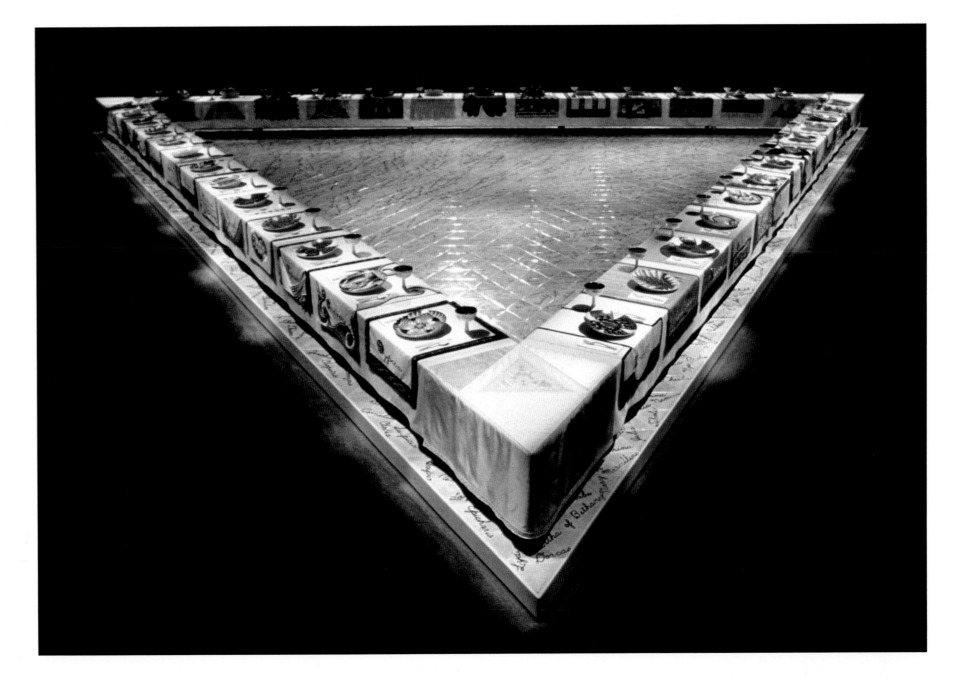

Tony Delap

Although I *started* as a painter, elements of both painting and sculpture have always been in my work. My work left the wall in the early sixties and I worked mainly as a sculptor for ten years. In the early seventies I began to combine painting and sculpture into wall-hanging paintings. One of my main preoccupations in these was the edge—the activity at the edge was becoming the content of the work. I developed a hyperbolic paraboloid wooden edge that changed course as it continued around the canvas, much like a Möbius strip. By creating a physical discrepancy between the front edge where the wood contacts the canvas and the back edge where the wood contacts the wall, the wall comes to be an integral part of the work and its aesthetic. Although the painting as object is still its hermetic self, it makes more than just a passive reference to the wall.

Another traditional aspect of sculpture—time—reinforces integrations such as these. The eccentric conformations of the painting's edges continually shift the form of the painting. In order to see the work in its totality, the viewer must move around it and observe its relationship to the wall from various viewpoints.

I was born in 1927 in Oakland and attended the Claremont Graduate School in Claremont, California. My studio and house are in Corona del Mar. My family and I like to take summer vacations in British Columbia photographing Haida Indian totem poles and going fishing. Trips to France and Spain, particularly to photograph architecture, are also something we like to do.

Jaipur Jinnée combines a partial circle with a square to create a strong, negative triangle of wall. The back of the square curves against the wall in such a way that another circle would appear if the curve were continued against the wall. The hidden elements behind the painting's surface harness the mysteries and energies that I find so demanding in this work.

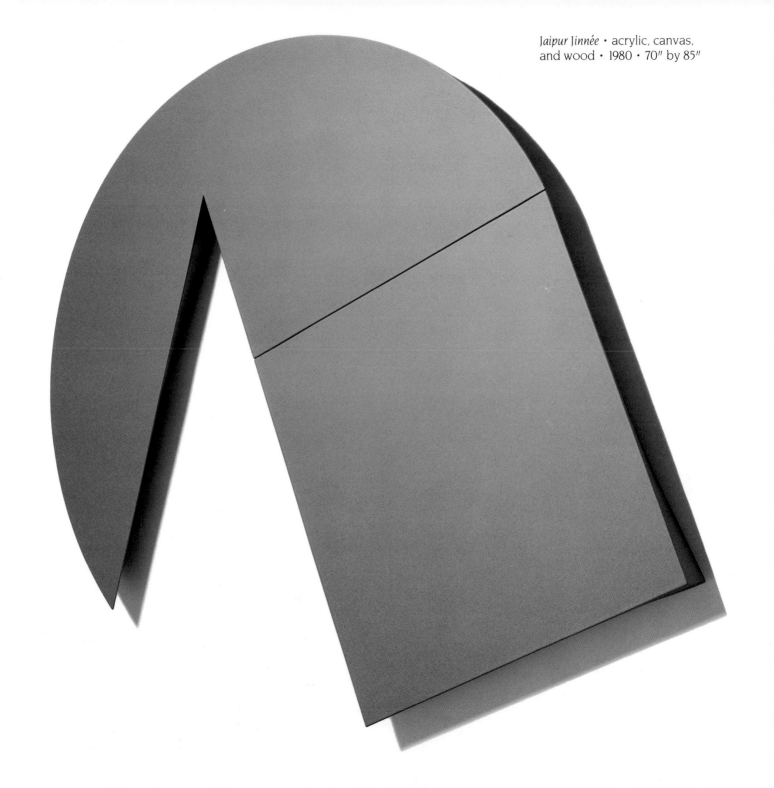

Jaipur Jinnée • acrylic, canvas, and wood • 1980 • 70″ by 85″

Richard Diebenkorn

I *had lost track* of this painting and now that it has re-emerged in a private collection I would like to see it reproduced and documented. Even though it is a painting from an earlier period, it is still of interest to me.

Untitled "M" · 1951 · oil on canvas · 43″ by 52⅞″

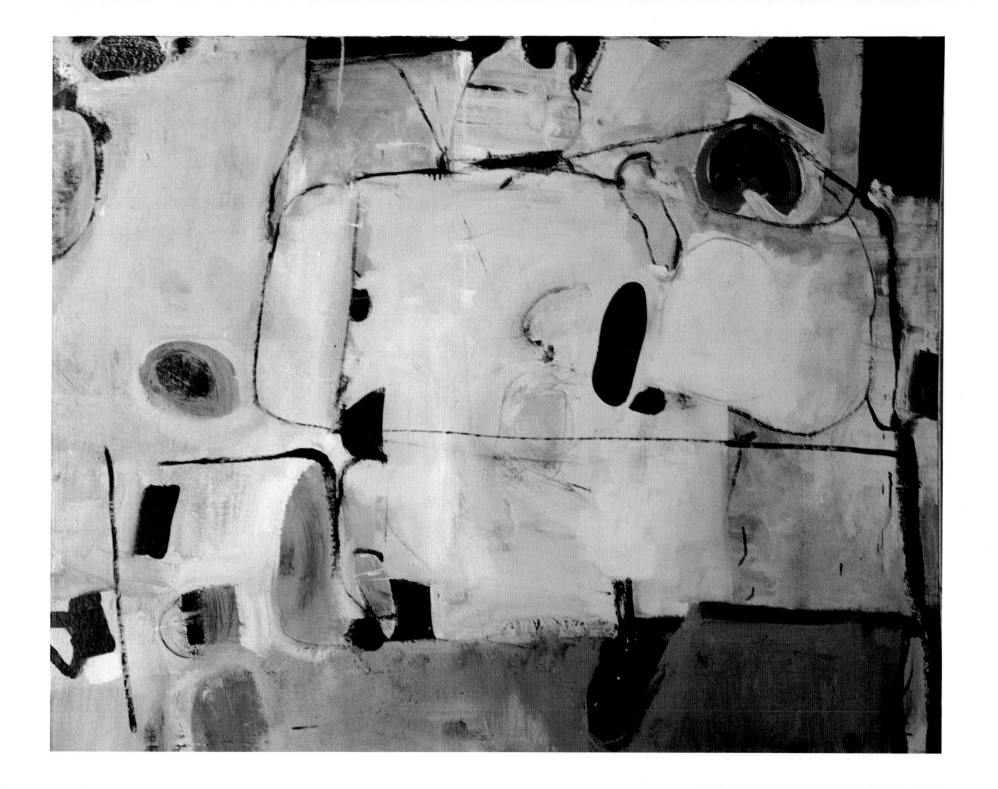

93

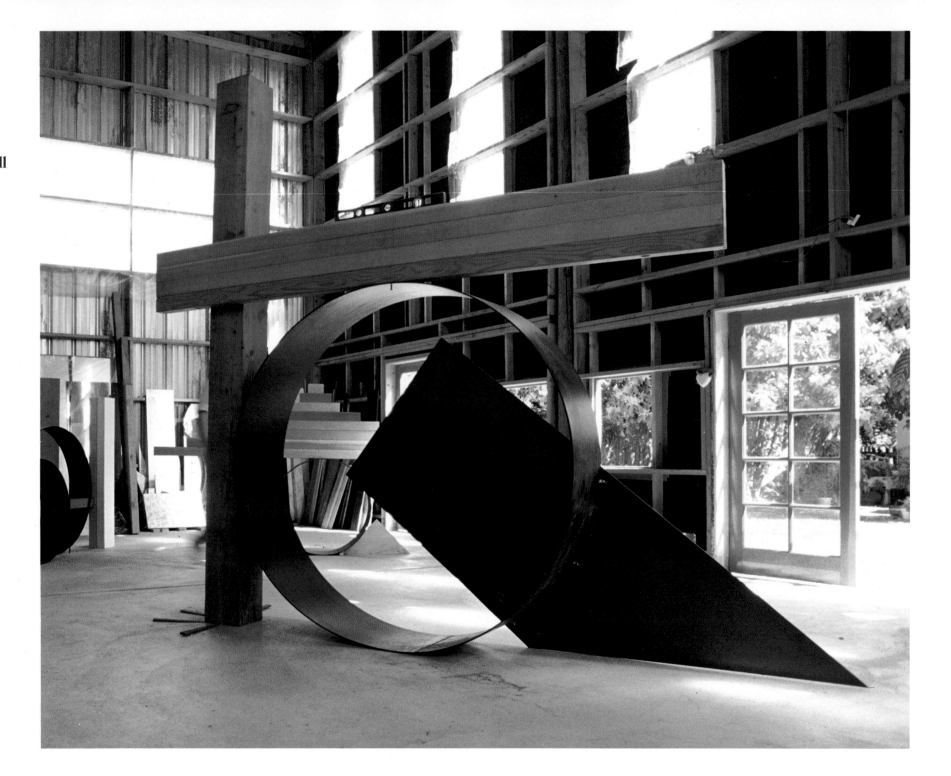

Working in scale is one of the great privileges of making art. Unlike an architect's model that is expanded into a building with no latitude for alteration and improvement, working in scale lets me deal one-to-one with space, scale, and so on.

My "palette" is arranged around the perimeter of my studio, stacked against the wall, spread out to provide both physical and visual access. By overlapping and mixing the materials—marble next to steel circles behind wooden beams in front of a metal triangle, etc. —the palette is loaded with information. It is always a very complex work or works in itself and is a constant source of new ideas. When new materials are added, the act is always a very conscious one. Finished pieces are often linked closely to the palette's arrangements.

In this work, the planes, connections, materials, color, and scale are of the new series of recombinant works that pull together ideas I have been dealing with for ten years. The circle first came in in 1971. Its use then was more a fulcrum than the subtle drawn-line quality it now has. The column also has resurfaced. Where once it was both connection and icon, the former role has been sublimated and its function is now an integrated icon or shape.

The maintenance of material as material is a consistent issue throughout this work. The natural colors and surfaces are essential to providing it with reality, or real-energy. Because you do not see a tree or person or "thing" in the work, its composition relies heavily on the natural state of the materials.

Architectonic references backed by traditional abstraction are the clues to understanding Ira. Another clue is the simple associations we use to place new physical information in our realm or sphere. The wall, plane, shapes, color, surfaces, materials, relationships, and connections are specific in that the alteration of elemental relationships causes a breakdown in the visual harmonics.

Ira • wood and steel • 1981
10' by 18' by 17'

95

Laddie John Dill

I *was born* in Southern California. I spent my childhood and adolescence in Malibu. I had been drawing and painting all my life, and by the time I graduated from high school in 1961, I knew that I wanted a career as an artist. In 1964 I began to attend Chouinard Art Institute in Los Angeles. I studied under Emerson Woelffer and Matsumi Kanametsu. Robert Irwin came by the school a lot, and I began talking with him. At this time, Irwin was moving into environmental art. Upon graduation from Chouinard in 1968, I set up a studio in downtown Los Angeles and worked out the light and sand pieces. I moved to Venice, California, the next year. I first exhibited in New York in 1971, and for the next few years divided my time between New York and Southern California. Late in 1972, I decided to move back to Southern California permanently. I rented the studio in Venice in which I currently work.

Untitled 1975 is a significant step in my development. Formally, it represents a transition from the horizontal to the vertical format. Conceptually, it represents a transition from a reference to landscape suggested by my earlier glass paintings and my glass/sand installations, to a figurative reference achieved by a more formal architectural structuring that developed into my D*oor* series of 1977.

Before 1975, my work consisted mainly of large-scale environmental installations of glass, sand, and neon. These installations had an aerial landscape quality. My first experience with the paintings was an attempt to transpose the information from the installations to a rectilinear format. Gradually, I began to incorporate architectural imagery suggestive of the human form and scale into the landscape imagery; images related to post-and-lintel structure, to doorways, and to windows. I continue to produce paintings that reflect both the landscape imagery and the architectural imagery. The materials I use are cement polymer, glass, silicone, and pigment. In 1979, I also began to produce drawings of pastel, oil paint, and graphite on rag paper.

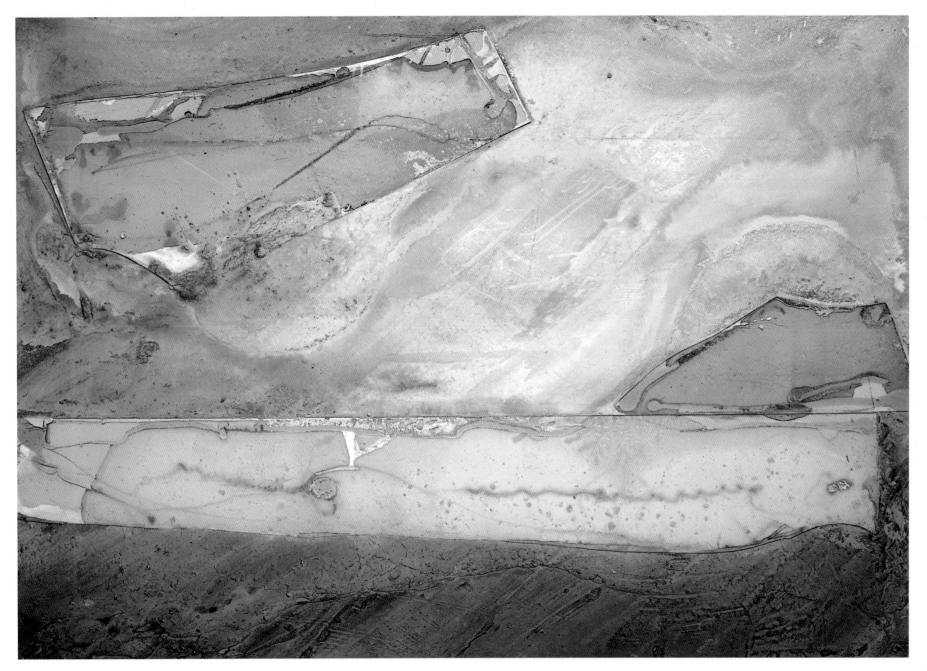

Untitled · cement emulsion,
plate glass, silicone, jade
pigment · 1975 · 84″ by 60″

Claire Falkenstein

From *early* childhood, I was aware of my need to create. I was constantly drawing, making paste-ups, and making objects out of clay from the riverbanks of my home town, Coos Bay, Oregon. As a young child, I was influenced by the home of L.J. Simpson, owner of the lumber mill where my father was an executive. This was my museum, where a wide range of artifacts stimulated me.

Years later, as a philosophy student at the University of California at Berkeley, I was deeply aroused by reproductions of Brancusi's sculpture. These were shown during a lecture in aesthetics by Professor Steven Pepper. During this period, I was drawing from life in a class given by a great teacher, George Lusk. He stimulated me to explore *myself* in form and color and to use the model as a point of departure rather than an object to be copied. That is when I became committed to art.

Living in Paris in the fifties shocked me into one of my most productive working periods. Europe offered the possibility of knowing contemporary masters of painting and sculpture and also becoming acquainted with the masterpieces of the past. I was one of the group of international artists supported by Galerie Stadler in Paris. Rudolphe Stadler, the owner and director, was a young lawyer from Switzerland who was nurtured from the beginning by Michel Tapie, a highly skilled aesthetician. Based on these associations, I had the opportunity to work and exhibit throughout Europe and Japan.

At the end of 1962, I returned home and settled in Southern California. Although I have exhibited profusely, my main concern has been the creation of large works in relation to living, to architecture and landscape—fountains, window screens, doors, wall reliefs, and free sculptures in architectural or landscape settings.

Finally, through this whole adventure, the consciousness of the twentieth-century disclosures and the effects of Einstein's theory of relativity has formed and directed me from university days.

Forum will be sixty feet by forty feet when it is completed. The photograph is a model of my concept for a socio-sculptural environment made of colossal Port Orford cedar logs some twenty-four feet long. The idea will be realized at the California State University campus in Dominguez Hills as a memorial to A. Quincy Jones, who did the master plan for the university. The source of the work was a part of my vocabulary in the work *Never Ending Screen*, conceived in Paris in 1957. The inner dynamics of the open spaces that result from the directional boundaries of the log construction allow the possibility of a flow of people moving through the structure. It will be a meeting place for students. The center, being a point of radiation, is a stage for speakers and musicians.

I have made two other monumental versions of the *Never Ending Screen*. One is the garden gates for the Palazzo Venier Dei Leoni, Peggy Guggenheim Foundation in Venice, Italy. The other is the stained-glass window screens and doors for the St. Basil Church in Los Angeles. The medium for both these works was steel.

Forum • Port Orford cedar logs
designed 1980 • 60′ by 40′

99

Sam Francis

I *paint* time.

we are always at the center
 of space
we are always at the center
 of time
we are always as far
as possible from both
east and west
we are always as far as
 possible from earlier
and later

there are as many images
as eyes to see

Untitled · acrylic on paper
1980 · 97¾″ by 44″

100

color is a
firing
of the
eye

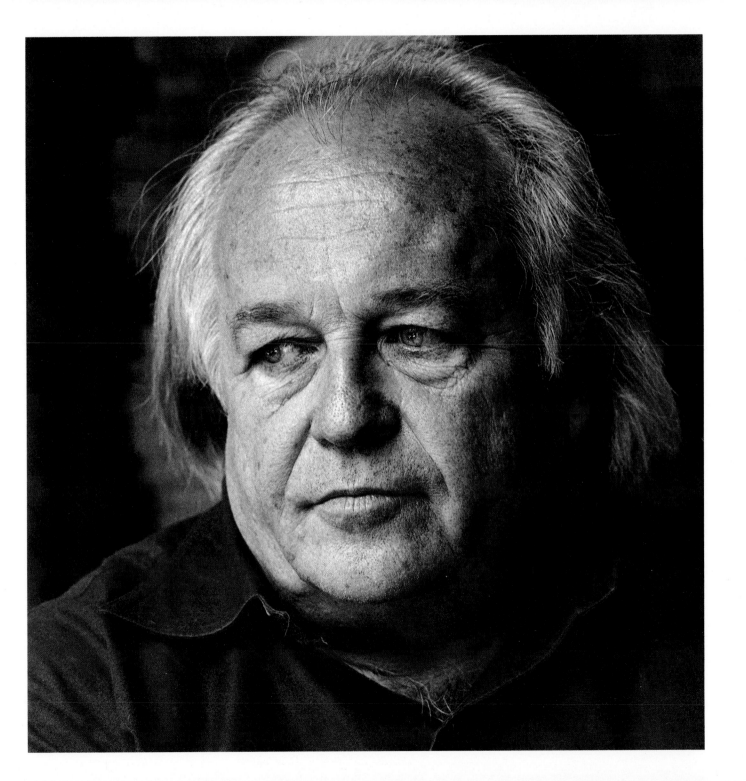

Lloyd Hamrol

The conditions for Highground provided me with an opportunity to integrate the work and the site to a degree beyond what I had found possible in previous projects. My concern in this piece was to designate a place of particular formal character in an otherwise visually ambiguous landscape. In particular, I wanted to establish a dialogue through the work between the materials, forms, and functions of the surrounding landscape and the architecture that could be addressed by the spectator on the level of direct physical participation as well as visual encounter. My intention was to construct an alternative tier of experience to the architectural realization of the site space. Circumstances of this kind are very provocative for my work.

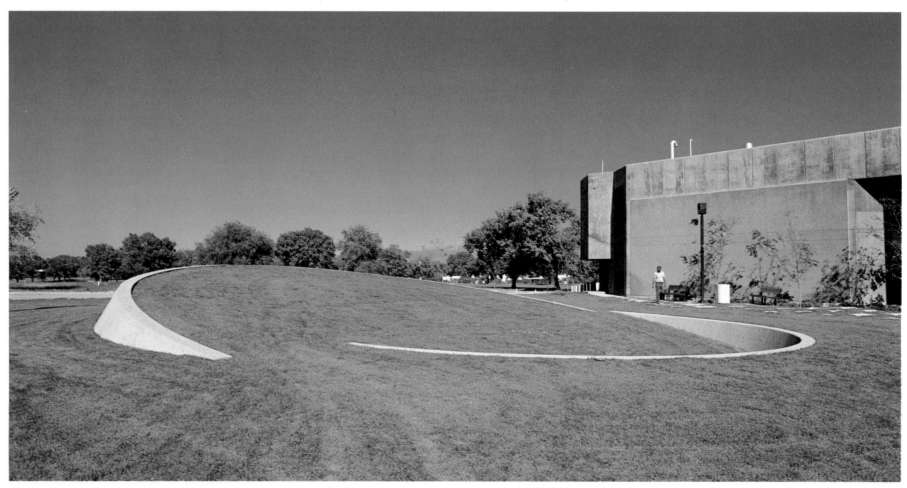

The events of World War II, as represented by the media of the day, played a large role in shaping my present values. My earliest drawings were of Axis leaders—behind bars. There is a recurrent theme in my work of rampart, revetment, and fortress, which I cannot help but think owes its genesis to that period in my life, reinforced over and over by images of a world continually at war.

As a child I was interested not only in drawing, but also science and natural history. I had difficulty in deciding which was most important to me as a career until I reached college and met the first "real" artist in my life. He was a painting teacher and a romantic eccentric whose chief claim to the title of "artist" was that he had set up his easel on the same Parisian streets as Maurice Utrillo. I was thrilled. I was eighteen and I made my decision.

Although I recognize few sculptors other than Nancy Holt, whose sensibility parallels my own, there are many whose work interests me. I have, like other sculptors of this period, been considerably influenced by Brancusi and by David Smith. However, architecture provides me with an unexpectedly large degree of nourishment. Monuments I have visited—Stonehenge, the beehive tomb at Mycenae, and Saarinen's arch in St. Louis—are noteworthy examples.

When I'm not making art I like to cook for friends, indulge in an occasional orgy of *haute cuisine*, run on the beach, or visit my favorite cities. Seattle's Pike Place Market and the St. Charles Street trolley in New Orleans, just to mention a few, are well worth the traveling.

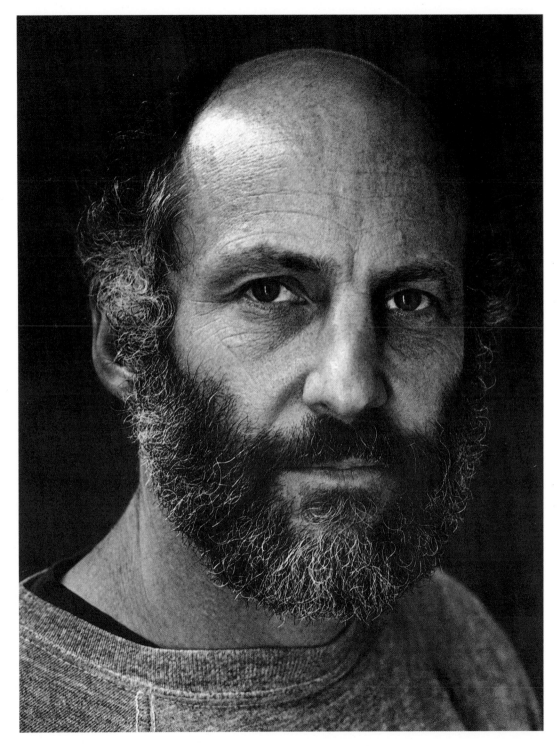

Highground • concrete and sod
1980 • 5' by 45' by 60'

103

Robert Irwin

I *was born* in Long Beach in 1928 and have continued to live in Los Angeles most of my life. It seems as if there is really no other choice. All my toys and games are here, the things I like to do best.

I'm not married and feel about kids the same way W.C. Fields did. I grew up as an artist, along with the other members of the Farus Gallery, in the beginning as a painter indebted to the Abstract Expressionists.

I now work in whatever form or material that seems appropriate to address my questions. I have become a questions addict.

Untitled · transparent
polyester scrim · 1979
50' by 100' by 14'

Craig Kauffman

I *painted* my first oil canvas when I was nine years old. It was a picture of my sailing an old sloop. I loved boats and making model airplanes. I've been making things ever since. I studied art at the University of Southern California and the University of California at Los Angeles. I especially liked Walter Hopps.

I live in the Los Angeles area and visit New York City. I've lived in Paris for periods of time. I'd like to spend more time in France.

This represents my new work.

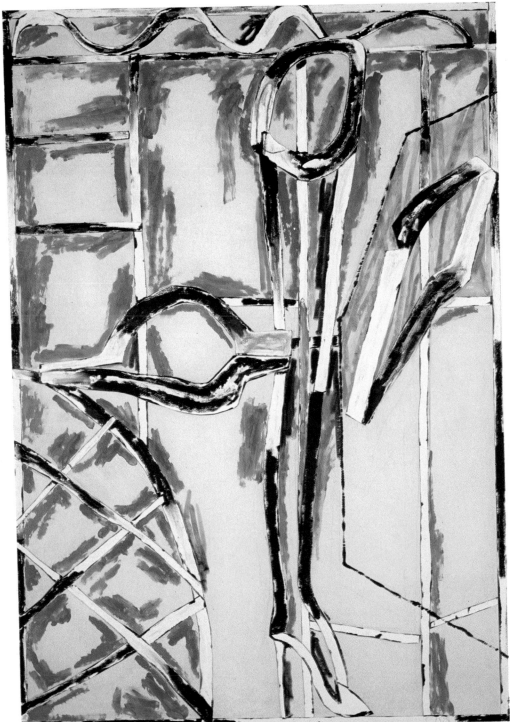

Leg with Garden Element
tempera, oil stick, and acrylic
on paper and silk • 1980–1981
84″ by 48″

Helen Lundeberg

From about the age of sixteen I looked on the arts as the most interesting field of endeavor, but I had no definite focus. I was an avid reader, in love with literature, and thought for a while that my *métier* might be writing. Although I had taken a few art courses in school, going to a real "Art School" seemed a remote and rather exotic possibility. Then, in a hiatus between junior college and a further stint in academia, a friend of my family offered to stake me to a few months at a small art school in Pasadena. That was my great good fortune. After about three months of "life class" and "composition" geared toward illustration, the teacher of those classes left for a vacation in Mexico and Lorser Feitelson took over. It was then that I learned to distinguish art from illustration—and that was *it*!

Whatever an artist can learn from another person I learned from Lorser Feitelson. This includes technical skills, an approach to historical art, and ideals of artistic ambition and integrity. Among historic artists, my admirations have ranged widely, from Piero della Francesca to Di Chirico's early works.

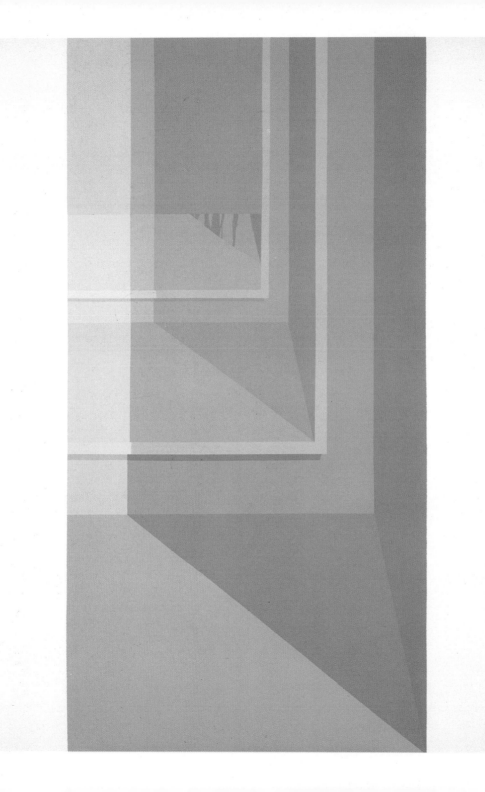

Gray *Interior* II is a recent work, one of a series of "gray" paintings, which represents some of the themes, pictorial devices, and structures that have recurred in my work for many years: closely related color (here, grays varied by small additions of raw umber and red), the use of areas of white-primed canvas as form, paintings within the painting, abstract evocations of landscape and architectural fragments, and cast shadows to enhance three-dimensional illusion. It also represents an intention, constant in my work, to create an entity both formal and lyrical, through strictly planned and executed organization of forms, color, and values.

Gray Interior II · acrylic on canvas · 1979 · 60″ by 50″

Lee Mullican

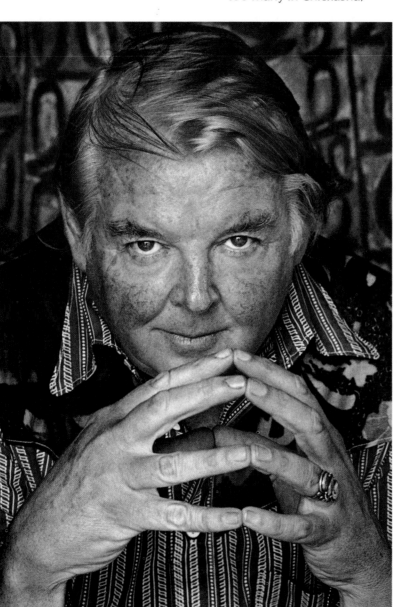

My *interest* in art began after high school. My induction in the army in 1942 gave me the chance to travel and to see major museums for the first time—there weren't too many in Chickasha, Oklahoma. I was drawing throughout World War II. I was a topographic draftsman, exploring the Pacific and working with mapping techniques and aerial photographs. That gave me a new way of looking at the world: abstractly. After the war I moved to the Bay Area. I became associated with the painters Gordon Onslow-Ford and Wolfgang Paalen. We prepared an exhibition called "Dynaton" at the San Francisco Museum of Art in 1951. The next year I moved to Los Angeles.

Travel has always been important to me: Chile, Peru, the cathedrals of England and France. In 1959 I took my family to Rome and established a studio for two years. In 1979 I made the first of what I hope will be many trips to India. The connection of man to nature in India and in the American Southwest has been a continuing passion. We built a house near Taos, New Mexico, in 1970 and spend our summers in that great, high, clean land. We collect primitive, ethnic, and folk art, with a great emphasis on the American Indian.

The *arrival* of the 1980s was to make a profound impression on me and my work. I was preparing a thirty-year retrospective of my paintings for the Municipal Gallery of Los Angeles. The 1970s were finished, thank God, and I wanted a new breath. The retrospective of my life and work added incentive to the need for a change. A new period would hopefully begin. I'd just finished four years devoted to a series of guardian figures, and while I was not sure that the examination of the magic personage as a subject had run its course, I was interested in a return to the kind of contemplative, organic abstractions I'd been involved with since 1947. The personal, formal techniques would continue; the precision and formality of vertical patterning on a black ground would continue. Yet I wanted to introduce the one obvious element for black that I had avoided: white.

In 1959 I spent a year working primarily in black and white—at a time when I was living with the extraordinary colors of Rome. But in 1980, this wouldn't be just black and white. Pervading accents of primary color would reach and add a minimal proportion. For the 1980s, I would risk a return to the "Source."

I have often worked with the idea of exploding parts—detail that can be pulled apart into separating units of a broader structure. The "Source" was a flower. I took the flower (actual and metaphorical) and exploded it (petals, stems, leaves, scent, etc.). I was given a widely diffused and open composition that would emphasize the play of the positive and negative, the decorative, the petal, the shapes. White striations would fall in almost computerlike patterns across the canvas. These striations—oil pigment applied with a broadbladed knife—have become a signature to my work.

One unit, a molecule, begins the creation of this world. This unit is exploded by density and change of value, becoming open to automatic, surprise-filled delivery. Each mark is its own incident. Each group of marks, a swarm, creates another incident. These additional fugitive parts, growing stroke by stroke, allow me to pull the flower apart and put it together again. The black-and-white canvas was creating its own molecular field.

This exploration of the incisive surface has created the fields of energy that have always been present in my work. Each stroke, each line of strokes, now white, now yellow: mark, red, mark, mark, mark.

The Source • oil on canvas
1980 • 50″ by 72″

111

Edward Ruscha

Sometimes this Art business is beyond the range of human comprehension, since the viewer is part of the experience. This makes it open to anyone's indulgence and the individual work falls or rises depending on who's looking at it.

The hardest thing to accept is that the number one rule is that there are no rules. This leaves it open-ended and makes the teaching of art impossible. It's maddening, isn't it?

No matter what style an artist operates under, he or she is still a little soldier to art history. If he were born fifty years earlier he wouldn't do the same things as he does today. Artists are so vulnerable that, despite the tough exterior, they are influenced by trivia that they would consciously reject. I find myself using things that once scared me stiff. So a visual artist has the right to never be questioned about what he does. Isn't this what they call "artistic license"?

As it stands, what do I know about silicones or sideburns or accidents? Not much except that I am committed to collecting thoughts and potential issues. The result can be vague if it wants to be. It's not important. The important thing is to create a sort of itch-in-the-scalp, to create a head-scratcher.

Silicones, Sideburns • pastel drawing • 1979 • 23″ by 29″

I DONT WANT NO S- SILICONES OR NO ACCIDENTAL S- SIDEBURNS

I *was born* in Omaha in 1937 and moved to Oklahoma at age five. The word "cartooning" had a powerful strength at around age eight. Whenever I saw the word I would get excited. I knew then that I wanted to be a cartoonist, if not an artist. Oddly enough, the word itself kept me going. India ink somehow played a big part in the tools-of-the-trade instinct.

Spike Jones influenced me in his stage style. When I was ten I got a gofer job with his band, running for things like a dozen eggs, which Spike would then grab and throw at his musicians. I was very impressed.

It was only natural, then, that I gravitated to the discovery of the Dada movement—another subject that can be appreciated by name alone. I hated "sketching." Images were more important to me than rendering. I left high school and Oklahoma in 1956 to go to art school in California. New York was too cold and intellectual.

On arriving I immediately realized that I had to unlearn everything, including the Catholic Church. At Chouinard Art Institute I got the one lesson I probably would not have gotten elsewhere. I learned to be dedi-

cated to my work. I was not running scared, because making money in art was the last thing that mattered.

A painting of a target by Jasper Johns was an atomic bomb in my training. I knew that I had seen something truly profound. Johns was unknown and so was his kind of art. The teachers said it was *not* art. Twenty years later, of course, what does their art resemble? Enough said.

The time I did at Chouinard was helpful, but less from the instruction than from my fellow students. I also became aware of the art of movies. I would forget the story but remember the emotion. I began to believe that it is not so much what you say that matters, but how you say it. This ruled out so-called emotional painting. Everything should be preplanned.

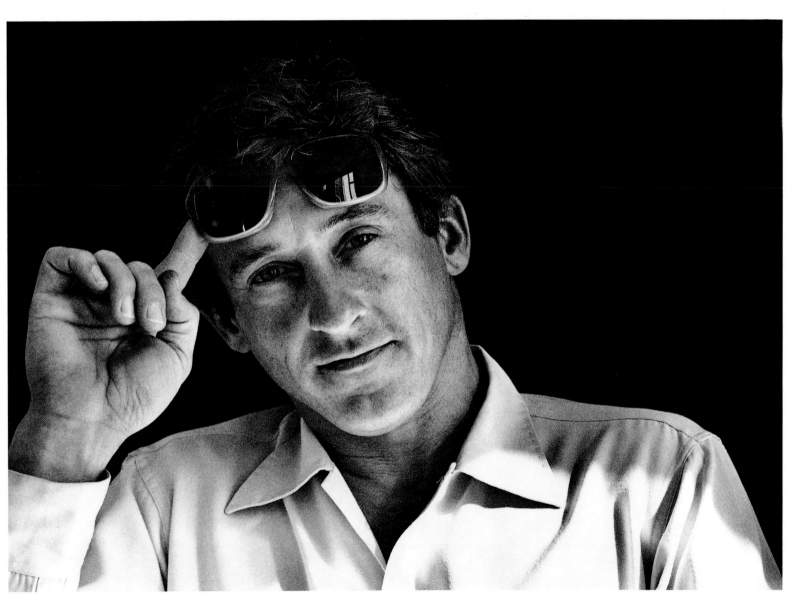

113

Betye Saar

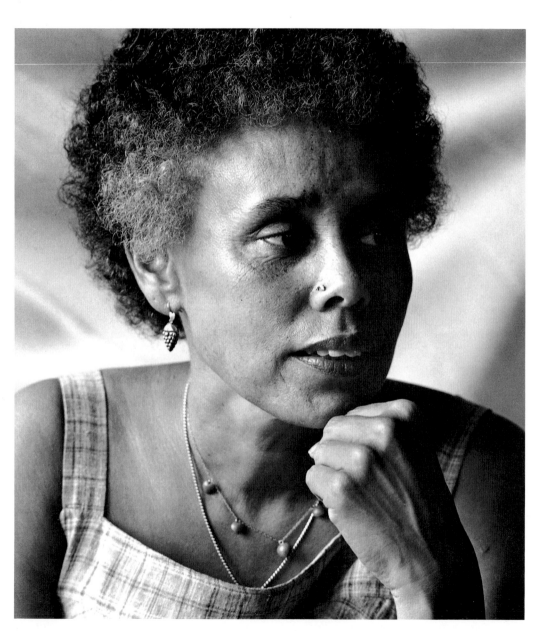

I *developed* an interest in art as a child at home and it grew in the schools I went to in Los Angeles and Pasadena. I was a design major until graduate school. Then I became interested in print-making, the transition to which was greatly helped by Dick Swift at California State University in Long Beach. Don Turner at the University of Southern California helped me understand what it is to be an artist.

I've raised my three daughters in an art environment. When they were babies I made art as they napped. Later we "made art" together. Two of them have now graduated from college and are artists in their own right. One is a published writer-artist; the other recently received her master's degree in fine arts. My youngest daughter directs her artistic energy in several different ways.

The content of my art has progressed in a somewhat spiral fashion, from ancestral history (ritual works) to family history (nostalgic works) to personal history. The more autobiographical the work, the more abstract it becomes. Also, there is less stasis, more kinetic energy, and the work is more holistic. My concerns, however, remain the same: the recycling and transformation of materials, the quality of texture, form, pattern, a sense of beauty, and mystery.

Time is a Matter of Choice is from a series of small-scale works that are an extension of large ritual or altarlike assemblages. They are like a personal ritual piece. I assembled old zinc and copper engravings and added other materials or objects. The title refers to spatial time as opposed to linear time.

Time is a Matter of Choice
linecut assemblage • 1979
6½" by 4¾" by ⅞"

Michael Todd

This is a sculpture from an ongoing series entitled *Daimaru*, which means "large circle" in Japanese. The circle has become a major compositional format for me over the past ten years. It seems endless in its possibilities. There are no traps in corners or along straight lines. Form seems to flow more naturally and freely in the circle, yet it provides creative restraints and discipline.

In Zen brush-painting, the circle is a master's problem. It represents everything and nothing, and in so doing, the universe. The *Daimaru* series is my attempt to master the problem and express my small part in the cosmos.

Daimaru XV · lacquered steel
1981 · 12′ by 12′ by 4′

I *was born* in 1935 in Omaha in the depths of the Depression, of Patrick, an Irish milkman, and Helen, a very pretty customer. I grew up in Chicago. My father noticed that my hand was rarely without a pencil or crayon and that I was always copying from comic books. He encouraged me to take drawing lessons and took me through the Art Institute of Chicago. The museum and its collection clung to my brain like barnacles. It was my paradise for years afterward. At the end of high school I had to choose between a career in science and a career in art. I recklessly chose art.

I studied at Notre Dame University and UCLA. Unlike the circle that is my present artistic preoccupation, the influences on my work are more like a spiral proceeding outward: my father, Robert Leader at Notre Dame, and John Paul Jones, William Brice, and Gordon Nunez at the University of California at Los Angeles.

I work in downtown Los Angeles, near Little Tokyo. I work until I'm exhausted. Twice a year I go to New York and Washington, D.C., to devour art. Occasionally I go to San Francisco for art and food and friends, I'm not sure in which order. I love to read, but there isn't enough time. Maybe some day I'll be able to read this book.

117

DeWain Valentine

The two most influential natural phenomena on my work are the sky and the sea. This transparent colored space excites and inspires me. I would like to have some magical saw that would allow me to cut up large sections of the sky or sea, but since that is impossible I have for many years made objects from cast polyester resin as a way of objectifying certain ideas and feelings.

I have also made such works as the environmental pieces that use daylight and interior spaces constructed to my specifications. *Catenary Light*, *Cantilevered Spectrum*, and *Curved Mall Spectrum* are examples of these.

My more recent glass works like *Double Pyramid* are another attempt to define and articulate my ideas and feelings in transparent colored space. Sometimes I think of these works as three-dimensional drawings.

I was born in Colorado in 1936. When I was young, my family traveled throughout the United States following my father's construction work. I went to the University of Colorado in Boulder, where I received a bachelor of fine arts degree in 1958. I went to the Yale-Norfolk Art School on a fellowship in 1959, and came back to the University of Colorado to get a master of fine arts degree in 1960.

In 1965 I moved to California to teach a course in plastics at UCLA Extension and settled in Venice. I began working with cast solid polyester and fiberglass-reinforced polyester. I exhibited these at the Dawn Gallery and at the Whitney Annual in New York in 1966. The same series was exhibited at the Los Angeles County Museum of Art in their exhibit "Sculpture of the 60s."

The next year I began working with various forms, such as double pyramids, rings, and wedge-shaped slabs. By 1968 I had developed a single-pour casting technique that allowed me to cast large-scale works such as six-by-eight-foot columns and an eight-foot-by-eight-inch slab. In 1970 I made a series of eight-by-one-foot concave circles and began a series of light and space environments that have continued through the present. The first was *Catenary Light*.

I began working with laminated glass in 1978. As with my earlier resin works, I was interested with the surface, the interior space, and the space beyond the work itself. And, as with the resin, the glass offered a great advantage since it could be used out of doors, whereas polyester could not. A major exhibit of these works was held at the Los Angeles County Museum of Art during October, November, and December of 1979.

In 1980 I received a John Simon Guggenheim Fellowship, and in 1981 a National Endowment for the Arts Fellowship.

Double Pyramid • laminated glass • 1979 • 103″ by 164½″ by 158¼″

Emerson Woelffer

My *first real* contact with modern painting came while I was working as an art student in the private gallery of Katherine Kuh in Chicago and at the Arts Club in Chicago. I saw my first exhibition of African and Oceanic carving as related to modern art rather than in a natural history museum. French art journals such as *Cahier des Arts* and *Minotaure* played an important part in developing my work. In years following, my work with Mahely Nagy led to meeting Man Ray, Léger, and Matta, to name only a few. All these experiences, along with subsequent meetings with Motherwell, Rothko, the photographer Suskind, and others were important to my work and thinking today.

In recent years the automatism approach to my work has led me into fired-clay sculpture—or ceramic sculpture, as some have it. My approach is also direct, working with a medium I think as sensuous as paint. The paintings and collages are giving to sculpture and sculpture is giving back to the paintings and collages.

This *is one* of the first collages of this size that I have created to date. It is also one of the strongest in color and was created partly in a semiautomatic fashion. Some of the shapes were torn without any thought or shape in mind. It was from these that the rest of the collage was directed. The materials are Color-Aid paper and Archer paper that I colored with acrylic.

In the beginning my collages were a way of thinking, much as a drawing is to other artists. After some years the collages became a means to an end rather than the provoking of an idea for a painting.

Italian Island • paper collage
1979 • 38½″ by 28″

Long winter nights in Canada kept a boy desperate for things to do, and playing with pencil, paper, and crayons was one of my favorite pastimes. In the meantime I was exposed to the world of stage and ballet and was dancing on stage.

My dancing teachers, Beale Fletcher and Jeanne Rodier, influenced me more than anyone else in my formative years, and the spirit of their energy and beauty—not to mention their grueling discipline—still guides my every step. It is no accident that my studio is a former dance hall and dancing school.

I have been influenced by such artists as Caravaggio, La Tour, Vermeer, Rembrandt, Seurat, and Pollack, so I like paintings with light and energy. I listen to Puccini, Verdi, Mozart, and John Lennon, so I like my paintings to really sing out.

following spread:
Spectrum Return • acrylic on canvas • 1975 • 5½′ by 14′

In *mixing* and preparing the colors for a painting, I depend heavily on mathematical progressions which are ultimately weighed in precise amounts of paint on a very sensitive gram scale. I follow the calculations as faithfully as a chemist. Interestingly, mathematical progressions in color are more related to growth rates of living organisms than to mathematical formulas.

But my painting does not simply obey laws of physics and mathematics. That would be boring art. It is the emotional and spiritual for which I search. It is to a unity and harmony in opposites resolving their conflict that my exacting ways are dedicated.

123

More information about the artists represented in this book can be requested from their galleries or sales agency; a partial list follows. The San Francisco Museum of Modern Art (Van Ness Avenue at McAllister Street, San Francisco, California 94102) is also a good source of information about these artists and their work.

William Allan
Hansen Fuller Goldeen Gallery
228 Grant Avenue
San Francisco, CA 94108
Odyssia Gallery
730 Fifth Avenue
New York, NY 10019

Robert Arneson
Hansen Fuller Goldeen Gallery
228 Grant Avenue
San Francisco, CA 94108
Allan Frumkin Gallery
50 West 57th Street
New York, NY 10021

Charles Arnoldi
James Corcoran Gallery
8223 Santa Monica Boulevard
Los Angeles, CA 90046

Ruth Asawa
Mae Lee
1128 Castro Street
San Francisco, CA 94114

Robert Bechtle
O.K. Harris Works of Art
383 West Broadway
New York, NY 10012

Fletcher Benton
John Berggruen Gallery
228 Grant Avenue
San Francisco, CA 94108

Tony Berlant
Xavier Fourcade Gallery
36 East 57th Street
New York, NY 10021

Elmer Bischoff
John Berggruen Gallery
228 Grant Avenue
San Francisco, CA 94108

William Brice
Robert Miller Gallery
724 Fifth Avenue
New York, NY 10019

L.A. Louver Gallery
55 Venice Boulevard
Venice, CA 90291

Joan Brown
Hansen Fuller Goldeen Gallery
228 Grant Avenue
San Francisco, CA 94108
Allan Frumkin Gallery
50 West 57th Street
New York, NY 10021

Vija Celmins
David McKee Gallery
140 East 63rd Street
New York, NY 10021

Judy Chicago
Diane Gelon
100 Hudson Street
New York, NY 10013

Jay DeFeo
Gallery Paule Anglim
710 Montgomery Street
San Francisco, CA 94111

Roy De Forest
Hansen Fuller Goldeen Gallery
228 Grant Avenue
San Francisco, CA 94108

Tony Delap
Janus Gallery
8000 Melrose Avenue
Los Angeles, CA 90046

Richard Diebenkorn
John Berggruen Gallery
228 Grant Avenue
San Francisco, CA 94108

Guy Dill
Janus Gallery
8000 Melrose Avenue
Los Angeles, CA 90046
Pace Gallery
32 East 57th Street
New York, NY 10022

Laddie John Dill
James Corcoran Gallery
8223 Santa Monica Boulevard
Los Angeles, CA 90046
Charles Cowles Gallery
420 West Broadway
New York, NY 10012

Claire Falkenstein
Tortue Gallery
2917 Santa Monica Boulevard
Santa Monica, CA 90404

Sam Francis
E. Kornfeld
49 Laupenstrasse
Bern, Switzerland

David Gilhooly
Frog Corbett Art and Garden
 Society
826 Oak Street
Davis, CA 95616

Sidney Gordin
Paule Anglim Gallery
710 Montgomery Street
San Francisco, CA 94111
Newspace Gallery
5241 Melrose Avenue
Los Angeles, CA 90038

Lloyd Hamrol
901 Pacific Avenue
Venice, CA 90291

Tom Holland
Hansen Fuller Goldeen Gallery
228 Grant Avenue
San Francisco, CA 94108
James Corcoran Gallery
8223 Santa Monica Boulevard
Los Angeles, CA 90046

125

Robert Hudson
Hansen Fuller Goldeen Gallery
228 Grant Avenue
San Francisco, CA 94108
Allan Frumkin Gallery
50 West 57th Street
New York, NY 10021

Mimi Jacobs
Care of San Francisco
 Museum of Modern Art
Van Ness Avenue at
 McAllister Street
San Francisco, CA 94102

Craig Kauffman
Asher/Faure
8221 Santa Monica Boulevard
Los Angeles, CA 90046

Helen Lundeberg
Tobey C. Moss
7321 Beverly Boulevard
Los Angeles, CA 90036

Richard McLean
O.K. Harris Works of Art
383 West Broadway
New York, NY 10012

Lee Mullican
Galerie Schreiner
115½ East 62nd Street
New York, NY 10012

Manuel Neri
John Berggruen Gallery
228 Grant Avenue
San Francisco, CA 94108
Charles Cowles Gallery
420 West Broadway
New York, NY 10012

Nathan Oliveira
John Berggruen Gallery
228 Grant Avenue
San Francisco, CA 94108
Charles Cowles Gallery
420 West Broadway
New York, NY 10012

Joseph Raffael
John Berggruen Gallery
228 Grant Avenue
San Francisco, CA 94108
Nancy Hoffman Gallery
429 West Broadway
New York, NY 10012

Mel Ramos
Louis K. Meisel Gallery
141 Prince Street
New York, NY 10021

Fred Reichman
Gallery Paule Anglim
710 Montgomery Street
San Francisco, CA 94111

Sam Richardson
Hansen Fuller Goldeen Gallery
228 Grant Avenue
San Francisco, CA 94108
Janus Gallery
8000 Melrose Avenue
Los Angeles, CA 90046

Ed Ruscha
Leo Castelli Gallery
420 West Broadway
New York, NY 10012

Betye Saar
Jan Baum Gallery
170 South La Brea
Los Angeles, CA 90046
Monique Knowlton Gallery,
 Inc.
19 East 71st Street
New York, NY 10021

Raymond Saunders
Stephen Wirtz Gallery
345 Sutter Street
San Francisco, CA 94108

Leo Valledor
MODERNISM
236 8th Street
San Francisco, CA 94103

Peter Voulkos
Braunstein Gallery
254 Sutter Street
San Francisco, CA 94108

William Wiley
Hansen Fuller Goldeen Gallery
228 Grant Avenue
San Francisco, CA 94108
Allan Frumkin Gallery
50 West 57th Street
New York, NY 10021

Emerson Woelffer
Gruenebaum Gallery, Ltd.
38 East 57th Street
New York, NY 10022

Paul Wonner
John Berggruen Gallery
228 Grant Avenue
San Francisco, CA 94108

Norman Zammitt
18 West Colorado
Pasadena, CA 91105

Richard Shaw
Braunstein Gallery
254 Sutter Street
San Francisco, CA 94108

Louis Siegriest
Triangle Gallery
95 Minna Street
San Francisco, CA 94105

Wayne Thiebaud
Allan Stone Gallery
48 East 86th Street
New York, NY 10028

Michael Todd
Gallery Paule Anglim
710 Montgomery Street
San Francisco, CA 94111
Charles Cowles Gallery
420 West Broadway
New York, NY 10012
Tortue Gallery
2917 Santa Monica Boulevard
Santa Monica, CA 90404

DeWain Valentine
69 Market Street
Venice, CA 90291

Daly City Public Library
Daly City, California

This book was designed by

Howard Jacobsen, Fairfax, California.

The text was set in Novarese by

Sara Schrom at Type by Design, Fairfax.

The title display is

hand-modified Sans Serifs No. 1 Condensed.

The mechanicals were prepared by

Craig DuMonte, Fairfax.

The four-color and duotone plates

were prepared and printed by

Dai Nippon Printing Co., Ltd., Tokyo, Japan,

on 100-pound TopKote stock.